SOMETHING ALL OUR OWN

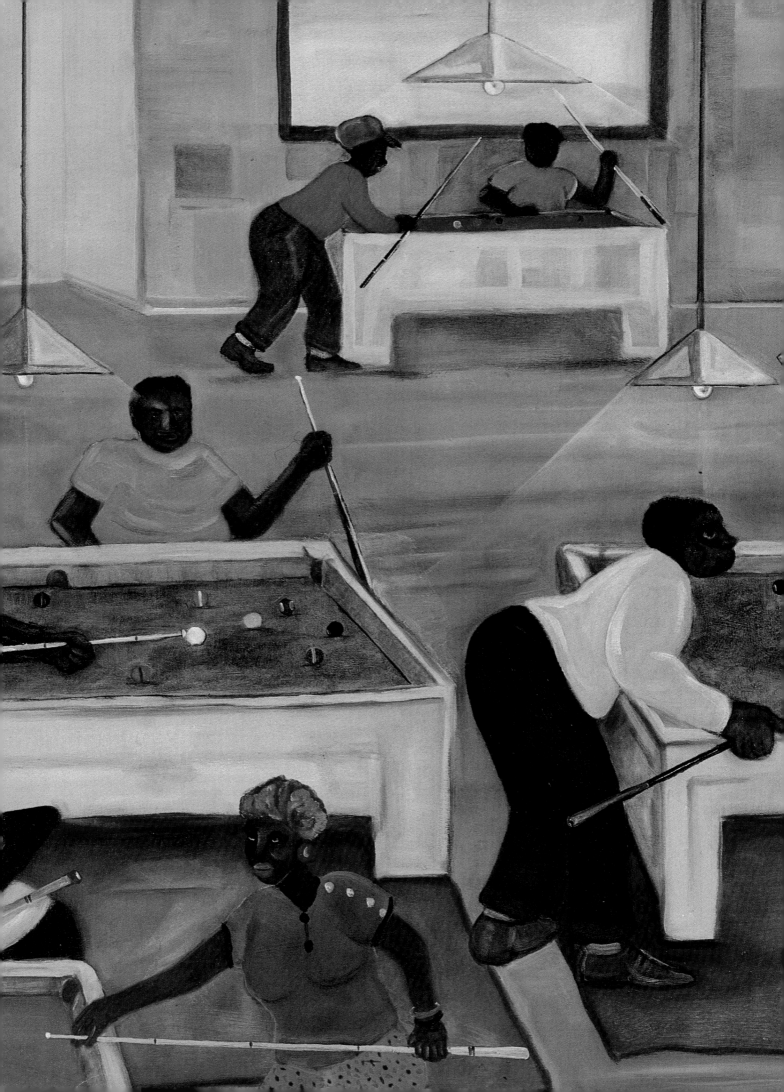

SOMETHING ALL OUR OWN

The Grant Hill Collection of African American Art

GRANT HILL

EDITED BY ALVIA J. WARDLAW

DUKE UNIVERSITY PRESS Durham and London 2004

Printed in the United States of
America on acid-free paper
Designed by Rebecca M. Giménez
Typeset in Scala with Ziggurat display
Library of Congress Cataloging-in-
Publication Data appear on the
last printed page of this book.
Frontispiece: John Coleman,
Eight Ball (detail). 1992.

CONTENTS

An Artistic Odyssey | 1
JOHN HOPE FRANKLIN

An Appreciation | 3
COACH MIKE KRZYZEWSKI

Something All Our Own | 7
GRANT HILL & CALVIN HILL

Extended Dimensions of Grant Hill | 13
WILLIAM C. RHODEN

A Brief Look at the History of African American Collections | 23
ALVIA J. WARDLAW

The Genius of Romare Bearden | 57
ELIZABETH ALEXANDER

Elizabeth Catlett: Making What You Know Best | 71
BEVERLY GUY-SHEFTALL

Catalogue | 79

An Artistic Odyssey

JOHN HOPE FRANKLIN

Perhaps the best way for me to express my appreciation for Grant Hill's quest for the beautiful and the meaningful in African American art is to recall my own experience in a similar, though modest, quest. I was in Lagos, Nigeria, in 1960 on a visit that coincided with ceremonies marking the independence of that country. Although I was there to observe some trends in higher education, I had time to take in some of the sights of the new nation's capital. I would stroll about the city in the early morning enjoying the sights and sounds of this, my first visit to sub-Saharan Africa.

On one of those mornings, I passed the studio of a sculptor who had several pieces on display in his window. One immediately arrested my attention. It was a simple, but beautifully carved, mahogany figure of a woman, whose motionless expression conveyed dignity and independence. Her hands were down at her sides, as if she were not about to speak, but neither was the viewer, for I was completely taken by her power and charm. Happily for me, the studio was not open, for I was attempting to persuade myself that I should not purchase the piece.

Each morning thereafter I would go by the studio to have another look at the sculpture. One morning, the studio door was open, and I went inside, ostensibly to see other pieces by the sculptor but actually to inquire if the woman in the window was for sale. The artist, Felix Idabour, greeted me, and when I inquired of the piece of sculpture that I had admired for days, he said that the title of the piece was "Benin Woman." He offered it for sale with one stipulation: that if he held a show in the United States

he would wish to borrow it, a favorite of his, for the show. With that understanding, I paid him and took my first art acquisition back to New York, where we were living.

That was the beginning of my quest. It has not yet ended, and if Grant Hill's appetite and tastes are what I think they are, he will be collecting for forty more years. I wish him well. ■

An Appreciation

COACH MIKE KRZYZEWSKI

I love Grant Hill.

Grant is the epitome of the person and the player that I love to coach and to have play in my basketball program at Duke University. I can still remember the first day I saw Grant on the basketball court and the first time I met Grant and his family. There was something unique and special about him and about his mother and father, Janet and Calvin.

As a recruiter of basketball talent, I certainly wanted Grant to be a part of our basketball program at Duke. And as a person, a coach, and a leader I wanted the Hill family to be a part of my life, for the rest of my life. My instincts were right on, and I can't tell you how glad I have been for the last fifteen or so years I have known Grant and his family.

I remember our first meeting. I told him what I tell all of our recruits at Duke: "I'm not going to promise you anything. If you choose Duke, you have to come in, work hard, and earn everything you receive." Grant took that to heart each and every day while he was at Duke and I believe he still believes that in everything he does.

It is that honest approach in which we began, and which has made an unbreakable bond between the two of us. We have a trusting relationship and one based on telling the truth.

His accomplishments on the court made him one of the all-time greats in not only Duke basketball history but Atlantic Coast Conference history, as he was recently named one of the fifty all-time greatest players in the league. At Duke he is one of just eleven players to have their jersey retired by the school—the highest

honor in basketball. He was a starter on two national championship teams.

One memorable story about Grant's playing career shows to me how he really believed in what we are trying to do here at Duke. He has an unconditional belief in me, and I believe in him in the same manner as well.

I speak about the Duke basketball train at practices and at games. The train stops at all games. As a matter of fact, each game is an intermediate stop on our journey. Some nights one of our kids becomes a man. For Grant I remember one of those nights.

It was the 1994 South Regional championship game against top-seeded Purdue in Knoxville, Tennessee. Grant was a senior, a consensus All-American, and a top candidate for National Player of the Year. He was the unquestionable leader of our team.

On the other side, for the Boilermakers, was the player most people considered the other Player of the Year candidate: Glenn Robinson. It was a big game; not only would the winner go on to play in the Final Four, but every fan would compare the two superstars.

During the first half, one of our freshmen, Jeff Capel, was playing particularly well—and I sensed that his matchup was going to be a key for us in the second half. So in the locker room at halftime, when I spoke to the team, I singled out Capel.

"You're the guy in the second half, Jeff," I said. "You're playing a great game." As I walked out of the locker room to talk to our assistant coaches, I heard Grant pipe up in the background: "That's right, Jeff. Coach is right! You can beat that guy. You can be great today."

Here was our team's star player, a senior, encouraging a freshman on the team during a crucial moment. As a coach, I was delighted because Grant's saying that to Jeff was much better than my saying it alone. It was another voice.

We came out the second half; Jeff scored the first five points to give us the lead. With about ten minutes to go, Grant picked up his fourth foul and I distinctly remember saying: "God, thank you. It's been a great run." I knew it was impossible to win this game with Grant on the bench. Of course I didn't let anyone on the team know my feelings at that moment.

With Grant on the bench, I noticed that Jeff Capel pulled the team together for a huddle and said, "Okay, guys. Grant carried us this far. It's time for us to step up."

Our team stepped up and played some of the greatest basketball I've seen. By the time I put Grant back in the game with three minutes to go, our team was well on its way to a thrilling victory and another Final Four. For Grant it would be his third trip during his collegiate career.

Capel ended the game with nineteen points, four rebounds, and seven assists. It was a monster game on a big national stage. That game was one of those magic moments when everything I had taught the players as a team came together. It did not depend on one guy. It did not depend on one voice.

After the game was over, Grant came up to me and apologized. He said, "Coach, I'm sorry." I put my arm around him as we were walking off the court, smiled, and said, "Grant, you won the game for us!" And he gave me this funny look. "No way," he replied. "I almost screwed it up with all those fouls." Then I said, "No, son, you won the game at halftime. You won it when you told Jeff Capel that he could be great today. And he was. In fact, he was the difference in the game when you were out. He lifted everybody else up to a higher level. You won the game for us just as sure as if you had been on the court the entire time. I'm proud of you."

Grant looked at me and nodded. He knew I was right.

As great as he was on the court at Duke, I love Grant even more for being the way he is off the court. He is sensational. He strives to be excellent in all aspects of his life—family, profes-

sion, business, and yes, art collecting. To be good at something you have to have passion for it. Grant Hill has passion for every part of his life. I love that about him.

Grant continues to have such a big impact in my life and I consider him a great friend. I look forward to our talks about basketball, or life, or family, or whatever may be on his mind or on mine. I trust his opinion and seek it out as often as I can.

Grant Hill is why I love coaching and why I enjoy what I do, every single day. It's a wonderful experience to be a part of someone special's life and see him grow from a high school kid, to a great college player and graduate, to a successful businessman, professional athlete, husband, and now, father. ■

Something All Our Own

GRANT HILL & CALVIN HILL

Growing up, I didn't want to "Be like Mike." I wanted to be like my father, to play football, to go to an Ivy League college and to do the things he did. Everyone who knows him knows he is a longtime collector of unique and imaginative art. As a child, our home was filled with paintings, sculptures, and artifacts from places throughout the world, but especially what my father calls "Third World" art. It had a profound impact on me and shaped my own thinking about collecting African American art and sharing my collection in this book.

—GRANT HILL

This book reflects our desire to share with others a collection of art and artists who we feel reflect our history, our culture, our heritage, and us. All the works of art in this collection, both individually and together, lift us, inspire us, and give us hope. They remind us of who we are, of what we have endured, of our triumphs and failures, of our hardships and our challenges as African Americans. They are also a constant reminder of the uniqueness and richness of the African American experience. Viewing them gives us courage to go on. We are constantly refreshed in our understanding of who we are, what we have endured, what we have overcome, and how much our contributions mean to American life and culture. We hope you are similarly touched.

All the artists in this collection pursued their creativity in the twentieth century. Most are well known, including giants of the American art world. They include Romare Bearden, Elizabeth Catlett, and Hughie Lee Smith. Others are less well known but significant contributors nevertheless. Among these are Arthello Beck Jr. and John Coleman. Like a lot of our history and achievement, our contributions as African Americans to twentieth-century art are less well known than we would wish. Even Elizabeth Catlett and Romare Bearden, clearly two of the most distinguished artists of the past hundred years, are not as known and appreciated as some of their contemporaries in the American art world.

As professional athletes, we are disappointed that African American achievement and artistry are more recognized and appreciated in sports and entertainment than in painting or sculpture. More people know Grant Hill than know Romare Bearden,

yet Bearden's career had a longer shelf life and more productivity than that of any professional athlete. Elizabeth Catlett, a native of Washington, is still creating into her eighties. A reigning doyenne of the art world, she lends her unique signature and vision to sculpture and printmaking. Although she has worked across the passage into the twenty-first century, she is only now enjoying the universal acclaim and recognition accorded lesser, mainstream artists. This inequity that befalls all these artists does not deter them from the imaginative spirit that inspires greatness. What a lesson for us all!

We hope you appreciate and enjoy these artists and their work as much as we do.

CALVIN: My interest in art probably came from my mother, Elizabeth Grant Hill, who was a seamstress, crocheter, and quilter. At an early age, she encouraged me to draw and tried to develop my artistic skills. We did not have much money but she also provided me with new coloring books. I always had an array of crayons, fresh crayons, because it was important to her that I appreciate color and the power of color in creative art. Once I was in school, I started visiting the Walters Art Museum in Baltimore with my mother. A scholarship to Riverdale Country School in New York meant a new regime, including weekly visits to museums and exposure to classmates who grew up in homes where their parents collected art. It was also the first time I met anyone who, when asked what he did, said he was an artist. No one in my neighborhood in Baltimore "collected" art and, to be sure, no one had a job as an artist.

GRANT: I am not an artist myself in that I do not draw particularly well and I do not think of myself as a creative type. I had very little training in art in the public schools of Fairfax County and, sadly, I know now that I did not avail myself enough of

the courses in art history provided at Duke. But I had one advantage that has accelerated my interest in art and collecting: I grew up in a home with parents who collected and appreciated artists and meaningful expressions of heritage and cultures throughout the world. My father, who shared the stories of his youth and the development of his collection, was especially instrumental and inspirational in my decision to collect African American art for my own home and family. The environment in which we live, especially the environment of our youth, influences the direction we take in life. Mine included not only an impressive collection of art in full view, but many trips to museums and galleries with my dad. For years prior to college, we had our father-and-son time together each year at the Final Four. At each location, my dad pushed me into galleries and museums to absorb unique expressions of artistic talent. He probably thought I went under duress. Now he knows the truth.

CALVIN: My art collection is fairly eclectic. I have pieces of African American art, other Third World art, pieces from Japan, China, and many places I have visited and enjoyed. One common theme in my collection is women, especially women of oppression throughout the world. The role of women in Third World societies has been underappreciated and underreported. As a reaction to the Moynihan Report, I did a paper at Yale on the positive role of women in the black American experience. I came to understand that women often keep it together by stepping into the breach to provide for and protect their families. My collection reflects this understanding. It includes sculptures and paintings by dozens of artists, among them R. C. Gorman, Allen Houser, Elizabeth Catlett, Francisco Zuniga, and Peggy Hopper. Their art captures the strength, nobility, and grace of women of color. This is consistent whether it is a painting of Hawaiian women by Hopper, or a sculpture of an

African American woman by Catlett, or a sculpture by Gorman of a Navajo mother. These images constantly remind me of my own mother and of other women, especially black women, and the sacrifice and dignity of their lives.

GRANT: I have been fortunate to hear many stories from my parents that define who I am and from where I have come. Getting to know yourself means understanding your background and appreciating those who have come before you. My father has a saying he uses in speeches: To be ignorant of your past is to remain a boy. The interest in my heritage as an African American is reflected in this collection. Maybe my collection is not as eclectic as my father's, but it includes a wide spectrum of well-known and less-well-known African American artists. My wife and I have filled our home with these precious works and we hope to pass that love and appreciation for art to our daughter. The thirteen Beardens in our collection span his career and give us a chance to appreciate the scope of his enormous talent. Arthello Beck's originally untitled painting, now known as *Confrontation*, was in my home before my birth. Art means different things to different people. His depiction of three torsos struggling together and apart may represent the battle one feels as a black man between emotion and reason. My mother visited Elizabeth Catlett at her home and studio in Cuernavaca, Mexico, while I was collecting her sculptures and paintings. Mrs. Catlett was delighted to learn that Tamia and I already had some of her work and wanted to acquire more. I was able to add several pieces she was working on at that time and to develop a personal relationship with Mrs. Catlett. Maybe I can emulate her and develop a talent that lasts for more than eighty years—much longer than the life of the perfect jump shot.

CALVIN: In entertainment and athletics, we African Americans are incorrectly thought by the mainstream to be inherently talented and gifted. In actuality, our contributions far surpass the capacity to excel at acting, singing, dancing, and dunking. In these pursuits, we are too often viewed as naturally creative and expressive. We have not enjoyed enough recognition of our creative and expressive talents in the world of art, yet there our talents are just as prolific as on the stage, field, or court. It pleases me to see Grant take such an interest in art as a collector and admirer of African American artists. We need athletes and other public figures that recognize their history and forgotten elements of their backgrounds. I hope his collecting and his production of this book will inspire other young people including athletes and entertainers to explore and highlight their heritage and history.

WE SHARE THE PRIVILEGE of an association with the artists in this collection. In some instances we know them personally, but in all instances we know them through their expressions and depictions. The things that inspired them to create each individual piece evoke in us deep feelings of joy, anger, and contemplation. Their ability to use their "crayons" to convey their passion and pride touch us in ways we can hardly express. We invite you to feel this power for yourself. ■

Extended Dimensions of Grant Hill

WILLIAM C. RHODEN

talkin' 'bout an aesthetic experience, your painting hit me like a lightning bolt—the gaunt arms, the long, slender youth muscled by the desire for social ascension leaping above a bushel basket that's fashioned to make a hoop, the young man is shoeless, his form perfect, the basketball cupped in his gigantic hand, a stark and rustic southern shack in the background, everything moving away from it, up & beyond. & this kid with the ball ain't playin' he's too lean & intense for nonsense. mind and body chiseled to score in a home-made basket at least a foot higher than the rulebook allows. plainly the kid is a winner. plainly your painting is a graphic of black hope. i'm cheering for us, cheering with all my heart, brother.

—MBEMBE MILTON SMITH, *tribute to Ernie Barnes*

I have encountered hundreds of athletes in two decades of daily sports journalism. For the most part, we have stayed on the periphery of each other's lives: They gave interviews, I wrote stories. Athletes perform. Journalists chronicle the beginning, middle, and end of their athletic lives.

My relationship with Grant Hill has been objective, but enduring. The quality of his character has made objectivity relatively easy. There has never been a need to explain wayward behavior, or back off of praise given during the course of his career. Hill has been exemplary, and this exhibit reflects the most consistent facet of his life and career—resilience and versatility. These characteristics are also cornerstones of art.

My timeline with Grant began in Dallas in 1985 at the Final Four: Georgetown versus Villanova. Villanova won in one of the great championship games in NCAA tournament history. What struck me upon meeting Grant was that at twelve years of age— he would turn thirteen in October—he was already taller than his father, Calvin, who stood 6 feet 4 inches. Sports writers notice these things. Journalists write the first drafts of history, so we are always looking for signs and symbols of the future. I had no idea that I'd be covering three Final Fours in which Grant Hill would be playing.

A day before the 1985 National Championship game, Calvin, Grant, and I met at the home of Mark and Linda Washington. Mark and Calvin were teammates on the Cowboys and their families became, and remain, close. Mark and I were teammates in

high school and college. Through him I met Calvin, through Calvin, Grant.

The conversation got around to children. Calvin was distraught: he admitted he could no longer beat Grant at basketball. This wasn't just fatherly bravado. Calvin really couldn't beat Grant. Not with pushing, shoving, or the allowable parental bogarting. He couldn't win. Grant had reached another level, and the rest is history.

Grant became a high school All-American. He attended Duke, where he helped the Blue Devils win back-to-back national championships. He was a first-round NBA draft pick, became co-rookie of the year, and at the time of this publication has played nine NBA seasons.

But the most significant accomplishment may be the forty-six works of art that make up this collection. For everything that Grant has done athletically, this exhibit is the beginning of an enduring legacy. Grant began collecting at Duke, though he was already grounded in black art by the time he reached college. His father began collecting in 1969, his first season with the Dallas Cowboys. He was introduced to collecting by two African American artists. Today Calvin and Janet Hill have an eclectic collection of about one hundred works, mostly by African, African American, and Third World artists. Grant accompanied his father to various galleries during their father-and-son trips to the Final Four.

One of the first pieces Grant purchased was a print of Ernie Barnes's *Fast Break*, a 1987 painting commissioned by the championship Los Angeles Lakers. Years earlier, his father had purchased a Barnes painting that had been commissioned by the United States Olympic Committee to commemorate the 1984 Summer Games in Los Angeles.

Barnes is a native of Durham. He was driven to paint, in part to fill a void. During a 1956 field trip to the newly desegregated North Carolina Museum of Art, Barnes couldn't find any paint-

ings of or by blacks anywhere in the museum. When he asked where such paintings were exhibited, the white attendant said: "Your people don't express themselves this way." That response encouraged Barnes to work feverishly to become an artist. Barnes, like Hill, played college and professional sports. In 1960 Barnes was the tenth draft pick for the Baltimore Colts; he retired in 1965 and threw himself into his art career. By his freshman year at Duke, Hill had a similar hunger for black culture. Like so many African American children who attend schools where African American history is not a priority, Hill entered college with a hunger for African American history and culture. He chose the right institution. Two of the nation's preeminent scholars of African American history were at Duke when Grant arrived in the fall of 1990: John Hope Franklin and C. Eric Lincoln.

As a freshman Grant was Duke's missing link from day one. In March 1990 UNLV had defeated Duke in the National Championship game; the loss was the widest margin of victory in NCAA championship history. A year later, with Hill in the lineup, Duke returned to the Final Four and played UNLV in a national semifinal game. Duke won. Hill was assigned to guard Stacy Augmon, UNLV's All-American senior. Augmon was shut down. Grant told his father before the game that Augmon would have to kill him if he intended to score. There was no murder: Duke won. The Blue Devils won the championship the following season as well.

Hill appeared in three consecutive NCAA Championship games, was a consensus first-team All-American and the ACC Player of the Year after his senior season. He won the Henry Iba Award as the nation's best defensive player in 1992–93. As a player, Hill has been the versatile star who could pass, defend, handle the ball. He could score but was not obsessed with scoring. He was a star player who had the temperament of a complementary player. This is the source of his greatness.

College was not a way station for Grant. Duke would not be a

place he would traipse through for a year or maybe two, then discard for the NBA. He matured, developed, read, and, as he has done in so many facets of his life, Grant followed in his father's footsteps. Calvin was a history major at Yale; Grant was a history major at Duke. Calvin played for the Dallas Cowboys from 1969 to 1974. The Cowboys won their first Super Bowl in his third season, in January 1972. After one year in the World Football League, Calvin played for the Washington Redskins from 1976 to 1981. Grant was the first-round pick of the Detroit Pistons and shared rookie-of-the-year honors with Jason Kidd.

Most stories about Grant Hill focus on the bloodline between father and son, as well they should. As Hill himself said, "Growing up, I didn't want to 'Be like Mike.' I wanted to be like my father . . ."

Grant calls his mother the glue that has held everything together. When we spoke about this touring collection of African American art, I asked Grant about his favorite piece. I asked which piece he would take if he were being exiled to a desert island and could only take one. He chose Elizabeth Catlett's bronze sculpture *Standing Mother and Child*, completed in 1978.

"That replicates the strength of women in the African American world," he said. "Black women are called on to be the foundation and the backbone of the family. I've seen that with my mother and her mother and I've seen that in my wife."

While her husband pursued his professional football career and her son began his basketball career, Janet was the bridge. Calvin watched the scoreboard, Janet watched who was keeping score, who was lurking around the periphery—and why. Janet Hill is the disciplinarian, the one who drives money changers out of the temple. Amid the swirling emotions surrounding a game or her son's notoriety, Janet Hill monitors the emotional equilibrium. She has shepherded two athletic lives.

Janet Hill was born in New Orleans. She attended Wellesley College in Massachusetts and graduated with a Bachelor of Arts in mathematics in 1969. She attended the University of Chicago Graduate School of Education and, in 1972, received a Master of Arts in mathematics. She has helped husband and son cope with retirement and injury.

When Grant came down with the flu his first season in Detroit, his mother flew to Detroit to play the role of nurse. She cooked the chicken soup, drove to the store in the snow, chatted with him as he went to sleep. She lectured him about taking care of himself, reminded him that he was living in a cold climate, to put a hat on his head, to wear socks—reminded him that he wasn't in Durham. Mostly she reminded him to pace himself. There was an entire season yet to play.

Grant was born in October 1972, the year the Cowboys won the Super Bowl. The thrill of that Super Bowl victory was eclipsed nearly twenty years later when the Hills watched Grant, then a freshman, help lead Duke to the national championship in 1991. "That was the greatest thrill," she said. "To be with Calvin and watch Grant and his team win the championship was indescribable."

This collection represents another sort of victory: The triumph of spirit, the enduring nature of art.

What separates Hill from many of his peers is his understanding of the fragile nature of sports and so-called stardom.

In 1994 Hill was the NBA's "new thing." He is now a seasoned veteran in a league built on youth. He joked about his Orlando Magic teammate, Drew Gooden, who excitedly told Grant how he used to wear a Grant Hill jersey in junior high school.

"At one point I was the new flavor, now I'm the old flavor," he said in March 2003. "Now people don't talk about me; I'm looked on as 'It's over.' It happens. Look at Dr. J., one of the greatest play-

ers in the history of the game. I was at an all-star game and saw him standing in a crowd. He just blends in with everyone else."

The difference between the visual artist and the athlete is endurance. Athletics is very much for the moment, in the moment. Art retains its vitality. Athletes lose their magic the instant they stop playing. The deafening applause, the limelight come to a halt. When the cheering stops, the silence is deafening. Athletic life begins with the body, and the body by definition is on a clock. There are a limited number of years to spring and dunk.

By the time the athlete retires, between thirty and thirty-five, fine artists are just coming into their own. Many do not hit their stride until their fifties, then spend the rest of their lives unlocking doors to creativity. Art is enduring. Bearden created practically until the time of his death at seventy-six. Catlett at eighty-eight continues to create.

The manner in which Grant has crafted his life reflects the artistic process: the long, meandering road versus the shortcut. Hill has already written a book, plays the piano, and has a passion for music.

What I'm saying is that Hill was not raised to be a basketball player. Because he was not defined by basketball, his career is not the sum of statistics. During a conversation at Duke during his senior year, Hill related a conversation he had with a friend who came from a tough background. The friend came to visit Hill at his parents' home and called the Hill home "the mansion." He said: "Why are you still playing? If my parents had it like this I wouldn't be playing." The idea was that his friend saw basketball as a job, an obligation, a way to make some money. Hill was able to enjoy the game, enjoy being a student at one of the nation's elite private universities. There was never a sense of desperation; his penchant to excel was not driven by a sense of "need," of having to support a family.

This is not to put down those who are driven by economic ur-

gency, who have to take care of pressing responsibilities. This is mentioned to illustrate what can be accomplished by a life that is not under the gun, a life that has time to think.

Grant began seriously collecting during his first season in Detroit. His parents' collection is larger, more eclectic. There are more Third World artists, lesser-known artists. His collection is classic—and richer. The Beardens and Catletts alone would make a collection. In time his art collection like his game will surpass that of his parents, not only in value but in depth and range.

The message behind the collection is as important as the collection itself. What prompted the exhibition was Hill's desire to raise the profile of African American artists, especially giants like Bearden and Catlett. He also wants to expose a wider public, especially young African Americans, to this visual map to their history. Too many pay homage to athletes to a degree that is unearned and out of proportion to the athletes' actual contribution to society. Yet too few African Americans, young or old, are familiar with the work of Romare Bearden, Jacob Lawrence, or Elizabeth Catlett. The double tragedy is that these giants are often overlooked by the mainstream as well. If African Americans do not honor their tradition, who will?

"I am a history major," Hill said. "This is a way to show us about our lives." Young people should be as familiar with Bearden as they are with Jordan and O'Neal; they should know the stories, the journey behind each life. Hill also wants to open the eyes of his peers in the NBA and other professional leagues to the value of collecting African American art. "There is a lot of affluence in our race," he said. "In sports, entertainment, business. We have an opportunity to show the world that we have a great tradition in art."

To understand why this exhibit is significant, we have to put the collection in the context of an athletic culture that stresses the here and now, the ostentatious display of having "made it." A

friend of mine who owns a gallery in Manhattan said he no longer attempts to sell art to athletes. He said, somewhat bitterly, that many athletes "aren't interested in visual art: they are interested in fancy cars, fancy houses, fancy clothes."

There are a growing number of African American athletes who do collect black art. Bernard King, the former NBA star, began collecting in the 1980s, as did Dave Winfield, the Hall of Fame baseball player. Clyde Drexler collects; so do Elliot Perry and Ray Allen. In February 2003 Chris Webber's personal collection of artifacts and other African American historical pieces went on display at the Crocker Art Museum in Sacramento. Darrell Walker, an NBA player from 1983 to 1993, had an exhibit at the University of Arkansas in 1996. Walker, who works in the Washington Wizards' front office, said he was heartened to hear about Hill's tour and collection. "This is the only way we can pass our heritage down," he said. "Can you imagine the impact on black art if high-profiled athletes begin to invest in African American art and spread the word? I think what Grant is doing is great."

Janet Hill once told me that the most difficult part of watching Grant progress from one level to the next has been sitting next to his father as he's done it. "The toughest part of getting older is the aging process I go through when I sit next to Calvin," she said. "Calvin does not take defeat well. I'm more of a 'pick yourself up and go after the next opponent' person. It's not that I accept losing, just that I've seen a lot in twenty-five years. I have seen tremendous victories, tremendous pinnacles. I have seen very difficult moments."

In March 1992 Grant Hill was involved in one of the greatest plays in college basketball history. With Duke trailing 103–102 in overtime, Hill tossed a seventy-five-foot inbounds pass to Christian Laettner; Laettner dribbled once, faked, and shot a fifteen-footer that beat Kentucky, 104–103.

Seven years later, Hill was involved in the worst moment of his

athletic life: He broke his ankle. In February 2003, for the third consecutive season in Orlando, Hill was forced out with the same ankle injury. Grant Hill had the fourth surgery on his left ankle in March 2003.

"The last three years have been a humbling experience," he said. "But this has also been the period I've grown the most. When you go through adversity you learn from it."

The rehabilitation will be the most excruciating test Hill has had to take as an athlete. He expects to be back on the court during the duration of this exhibit and I certainly won't be surprised to see his triumphant comeback.

At the same time Grant has turned an emotional corner in his sports life. He has glimpsed life after basketball, and has seen that the vistas are unlimited. He played, he saw, he conquered, and he's ready to move on. "I grew up with a certain perspective of athletics," he said. "I saw that when it ends, it ends. There's more to life than running the football and dribbling a basketball. The NBA is one chapter of my life."

His past has been exciting. I'm even more excited about his future. ■

A Brief Look at the History of African American Collections

ALVIA J. WARDLAW

The political vision that guided the Black freedom struggle from Frederick Douglass to Martin Luther King, Jr. rested with two goals: first the dismantling of racism within the legal, econo-mic, and social apparatus and the granting of democratic rights to African-American people; and second, the empowerment of the Black community in the context of culture, social relations, and daily life. This is what W.E.B. DuBois meant, in The Souls of Black Folk, *by the phrase "Of Our Spiritual Strivings." This is our sense of culture and beauty, our music, dance, and artistic sensibility, our quest for human dignity in our relations with whites. The struggle for free-dom has always been a search for authentic identity, a sense of "being-for-ourselves," and not for others.*

—MANNING MARABLE

To fully comprehend the depths of the African American's search for "authentic identity," one must regard the act of collect-ing objects of cultural importance within the black community as a holistic endeavor that spread its roots much more broadly than suggested by the twentieth-century notion of simply select-ing works of art for a home or other domestic dwelling. The his-tory of collecting within the African American community really began during the slave trade, when those Africans forcibly brought to the New World came wearing beads, bangles, anklets, neck-laces, and waist ornaments, and retaining a memory of remedies and healing methods that would be used for generations. Mate-rial culture plays a significant role in the maintenance of identity within the black community. Indeed, in her informative essay on the history of collecting African American art, Sharon Patton spe-cifically notes that the earliest artifact of African American cul-ture known to have been collected is an outstanding object of material culture, a seventeenth-century drum from Virginia, now in the British Museum.[1]

Distinctive foodways and accompanying recipes passed on for generations were especially evident in the black communities of the Sea Islands on the Carolina coast and throughout Louisi-ana. Had these recipes not been "collected" there would not be the detailed information available in current publications. A note to the writer of the book *Stirrin' the Pots in Daufuskie* from the granddaughter of one of the island's great cooks describes how recipes were learned and shared: "Anyway, when Mother and

Daddy first married, they lived with Gramma for a year or two maybe, and mama learned a lot of Gramma's ways to cook. So what I have learned from Mama (to be things like Gramma White cooked) I'm sending to you because I know she learned from Gramma, first hand."[2]

The sharing of seedlings for peppers, tomatoes, okra, greens, and various spices needed in the preparation of traditional foods of the African diaspora was an action of collecting that defied within the black community any boundaries of class, age, and geography, and established a collective memory alive at the table. Such collecting efforts exist outside the normal realm of cultural connoisseurship, and yet remain central to an African American focal point of accumulation, measured by the desire and the need to keep those things near at hand that are deemed important. The frequent misconception of African American art collecting in the twentieth century as being somehow a quite recent cultural apparition, springing forward from a *tabula rasa* without precedent, underestimates the complexity and depth of African American culture. A focus upon African American folkways dissolves the boundaries between material culture and fine art.

What was most essentially passed on and "collected" within the black family was land and homesteads, that equipment and those structures that would have been part of those homesteads, and any livestock owned by the family and grazing the land. Just as the Masai of East Africa held on to cattle, so too in the United States did young black farmers treasure their livestock. Accompanying this need for a homestead was the need for furnishings and, as mentioned, the cultivation of a garden. Many African American men of the nineteenth century and the early twentieth were multi-talented craftsmen. Such men tilled their farms and raised livestock; they often single-handedly built houses and barns, and created furniture for the home. Well-used and handcrafted furnishings were infrequently passed on to the next generation.

Some objects did survive, however, and have become part of a new generation's collecting vision. Derrick Beard, of Chicago, has established undoubtedly one of the most important collections of these often overlooked treasures, remnants of a difficult past. Beard's collection of African American artifacts, literature, and decorative art includes beautifully constructed beds, side chairs, pottery, andirons, and other objects necessary for the household.[3]

A fundamental element in many collections of African American art is the traditional art form of quilts made by black women—mothers, grandmothers, sisters, cousins, and aunts—for their families. Throughout the country, an impressive number of these quilts have been collected by family descendents, friends, or simply supporters of black culture. During the nineteenth century, strip quilts, vertically pieced together in the same fashion as West African textiles, were commonly seen in African American homes. These textiles, made to keep a family warm during drafty winter nights in houses with little heat, were made of immediately available materials—work clothes, worn dresses, feed sacks. Clothing recycled and used in the construction of quilts served to simultaneously pass on certain memories from one generation to the next. Missouri Pettway of Gee's Bend, Alabama, kept alive her husband's memory within the family by using his work clothes after his death to create a commemorative quilt that she made for her family.[4] Lettie North of Seguin, Texas, made beautiful quilts from cotton flannel, drapery material, and corduroy. She passed on thirteen of her quilts to the next three generations with specific instructions to her sister and grandson to always keep the quilts together as a body of work.[5] Alice Mae Williams, a quilter who grew up in Refugio County on Fagan Ranch, Texas, had fond memories of learning to quilt from her mother and mixed emotions regarding a quilt that she gave to her granddaughter: "My mother used to make quilts out of Croker sack and old pants, and she would tack them. She didn't quilt them, she tacked them.

She pieced a quilt and then she made the top part out of britches and then cover that. And she made some quilts with cotton. But most of the quilts she made them out of Croker sacks. . . . And when she passed. . . . I'm sure sorry that I gave it to my grand-daughter. I couldn't even cover up with it, it was so heavy."[6]

The famous Bible quilt by Harriet Powers, now in the Museum of Fine Arts, Boston, was originally purchased by a group of Atlanta University faculty wives for the university's collection. More immediately, Calvin Hill, the father of Grant Hill, has shared his thoughts about his mother's pastime of creating crochet ornaments for their home as well as quilts for the entire family. Although original items of hand-made clothing are more difficult to find in family collections, there is evidence as well that African American families kept as heirlooms a number of unique garments. In the 1983 exhibition "Homecoming, A History of the African American Family in Georgia," several examples of original family christening gowns hand-made by a relative as well as costumes from a Tom Thumb wedding were documented and preserved.[7]

In New Orleans, where black craftsmanship literally helped to build the city, a variety of craftsmen—brick masons, woodworkers, ironworkers, and plasterers—all have left their marks on the city. The preservation of black cemeteries has led to the collection and preservation on a group level of fundamental aspects of black history. Kevin Sinceno, a carpenter, describes best the idea of passing on a cultural tradition in his description of his work to preserve the shotgun house: "I love those old shotgun houses. It's a challenge . . . It isn't really about the money, just the challenge of taking that old house that everybody thinks is dead and bringing it back to life."[8]

In East Texas during the nineteenth century there developed a pottery tradition organized by three African American men, Hyrum, James, and Wallace Wilson, former slaves of John

Makemie Wilson Jr., who had developed a pottery that serviced the entire southwest region of Texas. After acquiring their freedom, the Wilson men created their own pottery, H. Wilson & Co., becoming the first African American business in Texas. The business thrived from the 1840s until Hyrum Wilson's death in 1884. Wilson pots have now become prized objects among collectors of Texas decorative arts. A descendant of Hyrum Wilson, LaVerne Britt, is currently spearheading an effort to acquire Wilson pots for a family museum; to date she has acquired five vessels. The Wilson family has recently developed a foundation to preserve the land at the site of the original Wilson pottery and to interpret the story of this rich legacy.[9]

In addition to family heirlooms such as quilts and furnishings, personal letters and documents were also kept within families when possible. Although rare, these documents do much to transport the reader to the period in which they were written and reveal a great deal about life for the African American family. In her book *A Love No Less*, Pamela Newkirk examines a series of letters between African American men and women. In a letter from "Ann, a Missouri Slave to Andrew Valentine, her Soldier Husband" dated January 19, 1864, from Paris, Missouri, Ann writes to her husband of the hardships that she and their daughter have endured since his departure, including being without money and "almost naked." She ends her letter with a postscript: "Send our little girl a string of beads in your next letter to remember you by. Ann."[10] Such intimate correspondence sheds immediate light upon the thoughts, values, and mindsets of African Americans from eras past.

The collecting of early masters of African American art such as Henry Ossawa Tanner, Robert Scott Duncanson, and Edward Mitchell Bannister was largely done by white abolitionists and liberal supporters of black artists. Tanner, the most prominent African American artist working in the nineteenth century, ulti-

mately traveled to Europe to work and settled in Paris, where he established a successful career. Before that he was known to have attempted twice to establish a career as an artist within the black community. In Atlanta, he set up a photography studio and, as Dr. Regenia Perry states, "hoped to earn a living by selling drawings, making portraits and teaching art classes at Clark College."[11] Tanner abandoned his photography studio because of a lack of support, and to date there has been no evidence of his works surfacing in the collections of Atlanta's black families. In her research, Julie McGhee points to Tanner's private disappointment at the lack of support from the African American community. "Really it makes me sad to see how contradictory 'my people' are to me; they appear to want to honor me but never at the price of a dollar."[12] Later, Tanner sold his gallery and moved to Highlands, North Carolina, in the Blue Ridge Mountains. Here Tanner sketched and photographed local African Americans, hoping to sell his images in this resort town. This effort was also unsuccessful, and Tanner returned to Atlanta, where he met his first major art patron, Bishop Joseph Crane Hartzell, a trustee of Clark College. The white bishop and his wife organized an exhibition of Tanner's works, and with the proceeds from their purchase Tanner was able to travel to Paris and study.[13]

The work of Duncanson and Bannister was similarly supported by white patrons. Duncanson received a major commission from the Taft family to create murals for their private home in Cincinnati, while Bannister involved himself with the development of the Rhode Island School of Design and received support from art patrons in Providence.[14] The sculptor Edmonia Lewis also received private support from American art patrons to sponsor her study in Rome.

That many African American nineteenth-century artists received a large measure of support from major white patrons does not mean that there were no black collectors of fine art at the

time. Henry O. Tanner received major support from Bishop Daniel A. Payne of the African Methodist Episcopal Church, a friend of the Tanner family. As an example of his vision, Payne established the "first black college 'art room and museum' at Wilberforce University about 1878 with his own and solicited funds."[15] In addition to research on the serious collecting efforts of Bishop Payne in the 1830s, the cultural historian Steven Jones has conducted specific and extensive research on nineteenth-century cultural activity among African Americans in Philadelphia. Among his most important findings is that in the mid-nineteenth century African American students in private schools kept elaborate scrapbooks that included favorite poems, paintings, and drawings by African American artists and writers. Among the works of art included in these scrapbooks are original works by such artists as Patrick Reason, Ada Hinton, and Sarah Matt Douglass, the sister of the artist Robert Douglass Jr. That such elaborate "scrapbooks" were compiled with great care and painstaking attention to content by school-aged youth indicates that the appreciation of fine art within the African American community was being passed down through generations within families and serious educational systems.[16]

Beginning in the 1830s the cultural climate in black Philadelphia was one of great energy, and there was a heady love for the black aesthetic fueled by a high level of community education. An impressive number of black bibliophiles came from the area. As the author and bibliophile Charles Blockson points out, by 1854 the African American community of Philadelphia was a focal point for the development of black cultural organizations such as the Banneker Institute. Robert Mara Adger of Philadelphia, David Ruggles, a freeman born in Norwich, Connecticut, and James W. C. Pennington of the Eastern Shore of Maryland, who worked early in his life as a blacksmith and later as a teacher, were all major nineteenth-century African American bibliophiles

who did much to shape the cultural climate of the times.[17] Within such an erudite atmosphere, an appreciation for all of African American history and culture was documented carefully and promoted through social events as well as educational activities.

Perhaps the most vigorous collecting within the black community was in the area of photography. Itinerant black photographers would travel through the countryside seeking black families to photograph. Often not able to purchase fine paintings or sculptures for their homes, these families insisted on family photographs—both group photographs and single portraits. Such photographs would take the place of the formal portrait, too expensive and not readily available to most. Photographs, therefore, would be passed down from one generation to the next with great care.

During the nineteenth century, African American photographers worked in earnest and opened successful studios in such far-flung places as Helena, Montana, and Monrovia, Liberia. James Presley Ball photographed the white, black, and Chinese communities of Helena, all of whom were anxious to have photographs taken as they had migrated to the area for work.[18] Augustus Washington traveled in early 1853 to Liberia, where he worked as a daguerreotypist. As Deborah Willis indicates in her research, black families who had emigrated to Liberia during the movement back to Africa as Americo-Liberians were eager to return images of themselves to families that they had left behind in the United States. Washington was highly successful from the outset as a photographer in Liberia. During his first week of work alone he made $500. In Washington, D.C., Daniel Freeman operated a successful studio at 1833 Fourteenth Street from 1881 through 1919. His subjects were the affluent and educated members of black Washington.[19] Willis states, "As with most portraiture, the photographs made in the nineteenth century were not intended for publication or public presentation. The African-American cli-

ents merely wanted to have their likenesses preserved for future generations."[20] During the early part of the twentieth century, the continuing need to memorialize African American families for themselves as well as future generations resulted in thriving photography businesses by photographers such as James VanDerZee of New York, Paul Poole of Atlanta, Addison Scurlock of Washington, and Louise Martin of Texas. These artists, as well as countless others, photographed members of the black middle class with great frequency and exceeding care and detail. In the process, they also documented a great deal of African American history that is now invaluable to both scholars and the general public in creating a truly comprehensive picture of black life. Black families throughout the United States—from Birmingham to Lansing, from Charleston to Seattle—have collected photographs of weddings, funerals, graduations, club meetings, group family scenes, portraits, military profiles, church outings, and conferences, all diligently documented by black photographers. In African American family scrapbooks, church bulletins, and yearbooks have been preserved many important memories of personal life and community history. Such photographs become the very real connection with a past that otherwise might too often have been passed on only through oral tradition.

The formal photographic studio portraits, such as those taken by James VanDerZee in Harlem, were in many instances the first and only portraits collected by African Americans. These photographic portraits became part of the conscious decision to construct a body of images (photographs) and artifacts (the family Bible, correspondence and deeds, coins and jewelry, handmade household objects) that were important to an individual or a family. Among the most sensitive of VanDerZee's photographs were the mortuary photographs that he took of family members, especially children, rendering their death in a poetic, visionary manner that made the loss less painful and easier to deal with in the

years to come. Because of high infant mortality during the 1930s these images became very important links to children who had died in infancy, and VanDerZee handled the photographs with imagination and sensitivity.[21] In formal portraits, how individual subjects chose to be viewed—as a hermit scholar, a lovely ingénue, a stately matron, a man with military experience—explained in a very real way how they wished to be "collected" in the future memories of their families and the general public. The sitters recognized the power of photography and chose to project what they felt was their most positive image into eternity.

An intense age of collecting by African Americans was ushered in during the Harlem Renaissance. Two figures emerge from this vibrant period as major collectors: one a bibliophile, the second a visionary scholar. Arthur Schomburg (1874–1938) and Alain Locke were both avid collectors who recognized the importance of collecting African American cultural artifacts and materials for educating the masses of young people who populated Harlem during a period of great energy and intellectual vitality.

Arthur Schomburg began collecting African American art and literature as part of his quest to learn more about black history after being told by his fifth-grade teacher in Puerto Rico that people of color had no history or heroes. A mentor to the artists Jacob Lawrence and Aaron Douglas and the organizing force behind the legendary literary salons held at the 135th Street Library, Schomburg recognized an immediate need for a source of information for the many artists, intellectuals, scholars, and families who were yearning to know more about their culture. In 1911 Schomburg co-founded the Negro Society for Historical Research. On May 8, 1925, the Division of Negro Literature, History and Prints opened in the 135th Street Branch Library. The collection was developed from gifts and loans from the black collectors Schomburg, Hubert Harrison, Charles Martin, George Young, Louise Latimer, and Mrs. John Bruce.[22] Soon after, the 135th Street

Branch Library organized an exhibition on African American culture in the 42nd Street main branch of the New York Public Library. The first of its kind, the exhibition featured many articles from the Schomburg collection and was on display for four months.[23] On May 19, 1926, with support from the Carnegie Foundation, Schomburg donated thousands of slave narratives, rare books, journals, and works of art to the New York Public Library's Division of Negro History. Over one hundred boxes of materials acquired by this dedicated collector were processed by the library staff.[24] For Schomburg, the acquisition of every material publication, as well as photographs, any small press items that he could locate, and other ephemera, became the focus for his act of collecting and educating. Schomburg had a mission during his period of patronage to not only amass these publications personally but also to share them in a structured manner with the general public. As he continued his collecting he became more and more interested in all the arts: Aaron Douglas, for example, as he created his four-panel cycle on black culture "Evolution of the Negro" for the 135th Street Library, was befriended by Schomburg.

Schomburg contributed to the activation of the black intellectual circles of New York City by making these materials available. Schomburg's papers helped in a very real way young artists such as Jacob Lawrence, who sought for his early painting series detailed information on the lives of little-known historical figures such as Toussaint L'Ouverture. The Schomburg Collection became the basis for numerous programs, projects, and sources of enrichment during the Harlem Renaissance. Today the center boasts one of the largest collections of black literature and history in the world. Scholars from throughout Europe, Africa, Asia, and South America visit the Schomburg to acquire immediate information regarding black history.

Dr. Alain LeRoy Locke, a pivotal figure of the Harlem Renaissance, began to look at the potential for Harlem literati and visual

artists to create their own cultural history. As the first African American Rhodes scholar, Locke visited major cities in Europe and recognized the emphasis that was being placed upon African art within contemporary art circles in Europe. Derain, Picasso, and Matisse were all greatly influenced by the power of West African sculpture. Locke's exposure to contemporary European tastes gave him a firsthand awareness of the vision of European modernists intrigued with African art. When he returned to the United States Locke was intent on sharing with his cultural peers the energized dynamics of African art that modernist painters were using to energize their own work. In Harlem he organized an exhibition of African art that predated by several years similar exhibitions at the Museum of Modern Art. Locke therefore used his own collections to illustrate the points that were made in his travels throughout Europe. His commute of many years between New York City and Washington served to spread information regarding the African diaspora throughout the intellectual communities of the east coast.

Throughout the late nineteenth century and the early twentieth, historically black colleges and universities played a major role in collecting and retrieving culture. A fundamental part of the legacy of these institutions of higher learning was the establishment of black history libraries, such as the Moorland-Spingarn Research Center at Howard University, the Hampton University Archives, and the Heartman Collection at Texas Southern University. Phonograph records, photographs, playbills, autographs, and minutes of meetings were some of the intellectual ephemera that were collected by black college professionals to develop significant cultural archives. Even the preservation of entire spaces and environments such as George Washington Carver's science laboratory (including the tools and handiwork of the scientist) at Tuskegee University, then Tuskegee Institute, have a place in the history of black collecting, for the act indicates an appreciation of

history that directly parallels the aesthetic sensibility reflected in the establishment of art collecting by African Americans. The 1999 exhibition "To Conserve A Legacy: American Art from Historically Black Colleges and Universities," curated by Rick Powell and Jock Reynolds, documents the historic efforts of African American institutions to establish outstanding collections of art.[25] The first historically black college to collect works of art for its permanent collection was Hampton University. At Hampton, works by Native Americans as well as traditional arts of Africa were permanently displayed. It was the sight of Henry O. Tanner's painting *The Banjo Lesson* at Hampton that encouraged the young student John Biggers to create his own art. Years earlier, a Hampton graduate, William H. Sheppard, created a major collection of Kuba art that contained four hundred works of traditional sculpture, in metalwork and textiles.[26] Sheppard had spent a number of years in the Congo and his friendship with the chiefs of the area provided him with a number of gifts that he brought back to Hampton. Viktor Lowenfeld, the Hampton professor, periodically lectured on the African art in the collection. A significant enrollment of African and Native American students on campus added to the importance of presenting cultural artifacts from these areas of the world as part of the Hampton educational experience.

James V. Herring was the first director of the Howard University Gallery of Art. Officially opened in 1930, the gallery received numerous loans and gifts of art from faculty, alumni, and friends of the university. In 1955 Howard was bequeathed the estate of Alain LeRoy Locke, including all his paintings, books, sculptures, and memorabilia.[27] His papers, housed at Howard University's Moorland-Spingarn Research Center, attest to his comprehension of the importance of both the artistic activities of African Americans and the times in which he lived. Locke appears to have kept every program, every invitation that he received during his busy days traveling between Washington and New York City. What dis-

tinguished Locke as a collector was his conscious use of his collection to underscore his mandate to black artists and intellectuals to become well educated with regard to their own culture. Professor James Porter, chairman of the Fine Arts Department at Howard, was the author of the first major text on African American art. Published in 1947, *Modern Negro Art* remained for decades the premier text on the subject.[28] For Porter, whose own art may now be found in the National Gallery, it was the task of a lifetime to document the accomplishments of black artists. His wife, Dorothy Porter, was a librarian who worked with him directly in his research and documentation for this invaluable publication. In the process of writing his book, Porter also documented early efforts of collecting within the African American community, including those at Howard, and during the course of their lives the Porters also developed one of the most expansive private libraries on black culture in the United States.

Also in Washington, the Barnett Aden Collection was developed by two professors at Howard, James Herring and Alonzo Aden, who gathered some of the most significant works of African American art during the first half of the twentieth century. Artists in the Washington area that were featured in exhibitions included Lois Mailou Jones, James Porter, and other distinguished faculty.[29] Many of these artists inspired younger artists such as Elizabeth Catlett and David Driskell, both graduates of Howard who distinguished themselves internationally as artists and curators. It was David Driskell who organized the first major survey of African American art, "Two Centuries of Black American Art," and it was his early experiences with the Barnett Aden Collection that undoubtedly led to his expansive awareness of the creative history of African Americans and to his own extensive activity as a collector. Soirées hosted by Herring and Aden were attended by major public figures, including Mrs. Eleanor Roosevelt. This min-

gling of the black intelligentsia of Washington with major political figures created a striking opportunity for cultural exchange.

At Fisk University in Nashville, the work of Aaron Douglas is central to the collection of art on campus. Douglas's mural series, the "Symbolic Negro History Series," was commissioned by Charles Spurgeon Johnson, Fisk's first black president.[30] The murals were the first works by an African American artist to become part of the permanent collections. Fisk received hundreds of African and African American works of art from the Harmon Foundation in 1967, when David Driskell chaired the fine arts department. In 1949 Georgia O'Keeffe gave to Fisk 101 works of art from the collection of her husband, the photographer Alfred Stieglitz.[31] The Alfred Stieglitz collection of modern art is one of the most important collections of its kind in the South.

When many black veterans returned home after World War II and went to school on the GI Bill, their recent exposure in Europe to ancient culture, cathedrals, cuisine, and art was matched with an environment on many black campuses that reflected an appreciation of their own culture. Hale Woodruff (1900–1980) traveled and studied in Paris, where he met Henry O. Tanner. Woodruff joined the faculty of Atlanta University in 1931 and established an art department at the university.[32] Woodruff was not content simply to establish an art department at the university, however. He also established an environment of collective support by developing an annual juried exhibition that was open to African American artists from throughout the United States. From 1942 through 1970 the Annual Exhibition of Works by Negro Artists, or the "AU Annual" as it came to be known among artists and collectors, offered opportunities for art collectors to support exhibiting artists by purchasing their work. The prizewinners in the exhibition became a part of the university's permanent collection. This was the first juried exhibition in the country by Afri-

can Americans and for African Americans, and the annual began the development of what is now one of the country's most important collections of African American art. The Atlanta University annual became one of the most sought-after exhibitions of participation in the country outside the Harmon Foundation exhibitions in New York. There thus developed around the Atlanta University Center, especially among faculty, an academic colony of art collectors who frequently purchased from faculty and visiting artists such as Woodruff.

At Texas Southern University, Dr. John T. Biggers and Professor Carroll Harris Simms organized a collection of African American art largely based on student works. Documented in *Black Art in Houston*, the collection comprises over one thousand prints, drawings, terra cotta shrines, and self-portraits, as well as works of weaving and photography.[33] Both art educators were influenced by their travels to Africa, and the remarkable collection, dating from the 1950s, takes an Afrocentric point of view, chronicling black history from slavery through the civil rights movement and into the technological advances of the late twentieth century. In Texas, the African American Museum in Dallas has its roots at Bishop College, which established a collection of African American art in the 1970s through the efforts of Dr. Harry Robinson. Encouraged by President M. K. Curry of Bishop College, Dr. Robinson helped to develop a core collection that included African and African American art as well as a number of books and other black memorabilia. Since the museum became independent it has acquired the Billy Allen Folk Art Collection and a number of nineteenth- and twentieth-century works. The Southwest Black Art Competition was a major source for adding to the collection, and works have been given to the permanent collection from artists such as Sam Gilliam and David Driskell. Representative Eddie Bernice Johnson of Texas has donated her papers to the museum and the archives have all the publication records for

Savoy Magazine. The museum has grown to become the largest African American museum of art in the Southwest.[34]

Outside black college campuses, thriving black middle-class communities were beginning to collect art through their support of African American artists. Cities such as Philadelphia, Chicago, Winston-Salem, Los Angeles, and Detroit all supported African American artists through individual or institutional collections. Indeed, in most major cities there was an active black middle class that existed largely around black colleges and universities and black professional circles. Physicians and other black professionals, inspired by travel and professional experiences, began in earnest to collect privately. After the war, the 1950s were an important period of black collecting.

A major corporate collection within the black community has for many years been that of the Johnson Publishing Company. Even during the 1960s the publishing company had amassed a major collection. Further, the Johnsons commissioned a number of works for their collection to be shown in their corporate headquarters. This early collecting, along with the development of programs such as the Ebony Fashion Fair, placed the publishing company in the forefront of African American collecting. Today the company can boast of one of the premier corporate collections of African American art.

During the civil rights movement there was an increased interest in the development of a history of African American culture among black families. A heightened awareness of the direct connection to Africa was evident among many artists. As African Americans strove to achieve a greater sense of who they were in this country, they also sought to find out more about their past. The artist John Biggers and his wife Hazel traveled to West Africa in 1957 and as a result began a lifelong development of a very special collection of African art. Their travels took them to Togo, Benin, Nigeria, and Ghana, and they collected works from all of

these countries.[35] The Akan were of special interest to John Biggers, and he collected a great variety of Akan combs. Hazel Biggers collected textiles from throughout West Africa including kente from Ghana, tie-dyed textiles from Nigeria, and traditional country cloth from Upper Volta. In similar fashion, there were many new collections of African art begun by African American ambassadors to African countries. Dr. R. O'Hara Lanier, ambassador to Liberia, Dr. Cynthia Perry, ambassador to several African countries, and Dr. Leonard Spearman, ambassador to Rwanda, all returned to Houston from their postings on the continent with impressive collections that they shared with African American institutions.

Perhaps one of the most significant events to increase an awareness of the collecting of African art within the African American community was Festac, the international festival of the arts that in 1976 took place in Lagos, Nigeria. During this celebration of African culture and the diaspora, an exchange between artists from throughout the world, there developed a deep appreciation of African history and art.

The 1970s thus saw a burgeoning of the collecting of African art within the black community. No small part of this interest can be attributed to the airing of "Roots" on American television. This awareness of African history and a subsequent need to visit the land itself led many African American families to visit the coastal cities of Dakar, Senegal, and Elmina, Ghana, both the sites of major slave forts. Later the recognition of a new South Africa without apartheid led to increased travel there by African Americans and to the subsequent collecting of African art from the southern part of the continent. African art in the 1970s and later was for many African Americans the first art that they collected, a major change and an indication of growth in the collecting of art within the African American community.

Within the past twenty years, there has emerged a critical mass

of African American collectors who have raised the bar for others. Certainly the best-known name is the Camille and William Cosby Collection. *The Other Side of Color: African American Art in the Collection of Camille O. and William H. Cosby*, the recently published book by David Driskell, documents years of collecting major African American art that began in 1967 with the Cosbys' first purchase of African American art, *Nude*, a Chinese ink-and-charcoal drawing by Charles White.[36] For the next nearly four decades the Cosbys began to amass what is now regarded as one of the most important private collections of African American art in the world. Just as collectors such as Schomburg and Locke were inspired to leave their collections to major institutions, so were the Cosbys inspired to build an institution dedicated to the promotion of African American art and culture. Located in the Camille Olivia Hanks Cosby Academic Center and dedicated in 1996, the Spelman College Museum of Fine Art now enriches the lives of countless art lovers in Atlanta and throughout the Southeast.

The Evans-Tibbs Collection was established by Thurlow Tibbs and housed in his grandmother's home in Washington. Events at the Evans-Tibbs Collection seemed to be similar to those that would have occurred during the Harlem Renaissance or at the Dark Tower, the well-known literary salon in Harlem. On one occasion, a birthday party was held for Alan Rohan Crite. The celebration of artists within their own times was a very important aspect of a collector's responsibility.

The Harriet and Harmon Kelley Collection of African American Art has been described by David Driskell as "one of the five most important collections of African American art in private hands."[37] Based in San Antonio, the collectors have amassed in less than two decades one of the most important collections of nineteenth- and twentieth-century African American art in the country. The Kelleys began collecting in earnest after seeing in 1986 a number of works by Henry Tanner in the exhibition "Hid-

den Heritage: Afro-American Art, 1800–1950," curated by Driskell. After seeing the magnificent paintings by African American artists at the San Antonio Museum of Art, the Kelleys became determined to learn as much as they could about these gifted men and women and their works; they became in a remarkably brief time some of the most knowledgeable and active collectors in the country. Today, the Kelleys frequently advise mainstream museums with regard to increasing the representation of African American artists in their permanent collections. As Jan Russell wrote in *Texas Monthly*: "Several times a day the Kelleys receive calls from museum curators, other collectors, or emissaries from foreign countries inquiring about borrowing or buying from their collection. Paintings they purchased in the eighties for a few thousand dollars are now worth more than ten times that amount. All together, it's a multimillion dollar collection."[38]

The major reason for collecting on the part of the Kelleys, however, is not material gain. Like other African Americans who collect African American art, the couple wish to share their love of their heritage with a broader audience. To this end, the San Antonio Museum of Art organized under the direction of Douglas Hyland an exhibition of 150 works that toured the country after opening in San Antonio and became the first private collection of African American art to be exhibited by the Smithsonian Institution. Presented by the Smithsonian's National African American Museum Project, the exhibition included works by Tanner, Bannister, and Duncanson, as well as major twentieth-century artists. The serious commitment of the Kelleys and their intense and unfailing support of African American artists have contributed to the appreciation of African American art on a national scale.[39]

In 2000, when the Kelleys' daughter Margaret graduated from Brown University, the Kelleys had the opportunity to share their collection with the Providence community. At Brown, the exhibi-

tion prompted the organization of the Edward Mitchell Bannis-
ter Society, an organization to support African American art.[40]
Ironically, the artist who had made a name for himself in Provi-
dence was now being further celebrated by African American
professionals over one hundred years later. The Kelleys have or-
ganized a foundation to continue their work at exhibiting and
documenting African American art. They continue to serve on
boards of arts institutions around the country and are constantly
providing ways for their collection to serve a larger public. Dr.
Harmon Kelley has successfully worked with the art editor of the
Journal of the American Medical Association to place works of Afri-
can American art on the cover of the journal, which is published
weekly. Henry Tanner, Archibald Motley, Horace Pippen, and Hale
Woodruff have been among those artists from the Kelley Collec-
tion whose works have been featured on *JAMA* covers with accom-
panying essays. The Kelleys are most proud of their ongoing
offering of publication rights to those publishing houses that cre-
ate textbooks for use in middle schools and high schools through-
out the United States. As a result of their granting the rights for
reproduction, these works are now seen by a number of youth
who may never have known about African American art.[41] Harriet
Kelley is a frequent speaker on panels regarding African Ameri-
can art and culture, and both she and her husband have befriended
younger collectors who are just beginning to amass major collec-
tions. They have enjoyed, for instance, spending time with the
former Toronto Raptors coach Darrell Walker, who has himself
developed a major collection and visits the Kelleys whenever he
is in San Antonio. Their national efforts were formally recognized
in 2000, when the Texas House of Representatives commended
the Kelleys for "their contributions to the advancement and en-
joyment of African American art."[42]

Another major collector is Dr. Walter O. Evans. While stationed
at the Naval Hospital in Philadelphia, Dr. Evans began to visit area

museums, and it was during these journeys of self-enrichment that he became acutely aware that from Washington to New York City he "never saw art by African Americans in these collections."[43] In 1964, while at Howard University, he availed himself of the culture on the campus at Howard, including lectures by speakers as diverse as Sterling Brown, H. "Rap" Brown, and Dr. Martin Luther King Jr. It was at this time that Dr. Evans made his earliest purchase of art, a portrait of Malcolm X by Jan Horne, an artist unknown to him.[44] Even as a young collector, Dr. Evans had the vision of an activist when he began his collecting in earnest. In his home in Detroit, he frequently hosted cultural salons to which he invited artists and major figures such as Rosa Parks, Gwendolyn Brooks, and others to exchange ideas and thoughts. During visits of distinguished artists to Detroit, Dr. Evans invited them to speak at educational institutions such as Wayne State University and the University of Michigan, Dearborn. In 1979 Dr. Evans hosted a benefit for Romare Bearden in his home. The many discussions and exchanges prompted by the art in his collection led Dr. Evans to utilize his collection for educational purposes as well. He has given lectures illustrated by photographs of the many artists and intellectual celebrities that he has visited over the years, thus demonstrating the personal level that collectors work at as they expand their experiences as collectors.[45] Through the Walter O. Evans Foundation for Art and Literature, Dr. Evans has circulated a major portion of his collection throughout the United States. Included in his collection are works by Bearden, Jacob Lawrence, Edward Bannister, Robert Duncanson, Henry O. Tanner, Richard Hunt, and Archibald Motley, among others. An avid bibliophile, Evans has collected letters and documents by and about Malcolm X, Zora Neale Hurston, James Weldon Johnson, and W. E. B. Du Bois, thus underscoring the need to preserve not only fine art in our community but those documents that have special meaning to African American history.

Walter Evans can look at the history of collecting African American art from a unique vantage point: he collected for a number of years when the works were not highly regarded, but now the works are keenly sought-after by mainstream museums and institutions. States Evans: "Collectors of African American art starting out today have advantages not readily available to me when I began. There were no models upon which to base my collecting practice. Curators at major museums and gallery owners were largely uninterested in works by African Americans. Scholarly research in the field was in its elementary stages. In addition, very few private collectors cared for the subject, and there were no art fairs and very few symposia. The failure of the news media to hire African American art critics or, at the very least, those knowledgeable about this type of art compounded the problem."[46]

As a bibliophile, Dr. Evans continues to collect works that are associated, in the tradition of Arthur Schomburg, with African American history. Dr. Evans's collection of correspondence by Malcolm X, for instance, represents an appreciation of history that only later becomes important to the general public. As Evans has written, "I am still searching for *Appeal . . . to the Colored Citizens of the World* by David Walker. . . . and a book of poetry entitled *Les Cenelles,* edited by Armand Lanusse."[47] It is this awareness that makes the Evans Collection much more than a collection of art; it is a personal compilation of art and artifacts that reflect the richness of African American culture. The dedication that Dr. Evans brings to his work as a collector defines his commitment to perpetuating an appreciation of African American art. He serves on a number of boards, including those of the Margaret Walker Alexander Research Center at Jackson State University in Mississippi, and most importantly was the president of the Jacob Lawrence Catalogue Raisonné Project. This multimillion-dollar project resulted in the documentation of all of the works created by Lawrence, the first such project dedicated to an Afri-

can American artist. Recently, Evans and his wife Linda established the Walter O. Evans Foundation for Art and Literature.

The most outstanding African American collector of black folk art is Dr. Regenia A. Perry, distinguished professor of art history and only the second African American to receive the doctoral degree in the field. In general, the collecting of art by self-taught artists is an area that has not received much attention from black collectors. For many it seems to have no value. But non-black and especially European collectors are fascinated by the vernacular art of blacks. Since the 1960s Dr. Perry has been collecting the work of self-taught African American artists throughout the United States. The work of these often-ignored artists has largely been collected by non-black art patrons. Dr. Perry has been one of the few African American collectors who have recognized the value and ingenuity of this body of artists. In addition to documenting the works of those artists that she has collected, Dr. Perry has organized numerous exhibitions on African American folk art and was one of the curators of the first major exhibition on the subject, "Black Folk Art in America," organized by the Corcoran Gallery of Art in Washington. She has also been working with the families of the artists to preserve and chronicle the works in the black community. Dr. Perry circulates her collections throughout the country, paying special attention to historically black colleges and universities and to African American museums in the South.

African American artists have themselves also been collectors. Lois Mailou Jones, who lived part of her life in Haiti, had an extensive collection of Haitian art as well as works by other African American artists. The New York artists Benny Andrews and Camille Billops have developed for decades archives on African American artists throughout the country. The collection of David Driskell is the best-known of this group. As the artist who developed the watershed exhibition "Two Centuries of African Ameri-

can Art," Driskell has been paramount in placing African American art in the forefront of discussions regarding American culture. The process of documenting African American art was furthered in many ways by Driskell's exhibition, and his studies extended the groundwork that had been established by James Porter in *Modern Negro Art*. A tribute by Stephanie Pogue in the catalogue for the exhibition, *Narratives of African American Art and Identity: The David C. Driskell Collection*, indicates the significance of Driskell as a collector who was equally an artist and educator: "He has been a steady voice for the recognition and excellence of African American art as an integral and significant part of American art. His research in this area has led to many associations that have been helpful in his life's work. He has largely defined the field of African American art history and brought recognition of a vast body of artwork by African American artists to the world community."[48]

The serious collecting efforts of David Driskell have pointed to the emergence of a new awareness of African American art among private collectors and public institutions. As indicated in the exhibition catalogue, Driskell's collection "spans almost four decades and includes African art, nineteenth-century African American art, European art, and Euro-American art."[49] As Keith Morrison points out in his discussion of Driskell as a collector, Driskell learned about collecting from "two kinds of sources: professors such as Alain Locke, James Porter, and James Herring, at Howard University; and private collectors such as Duncan Phillips, Albert Barnes, William E. Harmon, and Carl Van Vechten."[50]

The vision that Driskell brings to his collecting is a result of his sensitivity as an artist as well as his keen awareness of the art world. His many years at Fisk and his working first-hand with Georgia O'Keeffe in organizing the Stieglitz Collection committed him to documenting with care and detail the works of African American art. At Howard his experience at the Barnett-Aden Col-

lection led him to understand, much as his professor Alain Locke had understood, the powerful nature of art as a mediating force in the arena of human exchange. It is this wide-ranging view of African American art that enabled Driskell to organize the exhibition on two centuries of African American art, a profoundly important exhibition for young scholars that continued the work done by Porter in his book *Modern Negro Art*. As a professor of art and art history during his entire career as a fine artist, Driskell has drawn on his love for collecting as a source of inspiration for his students. His many works collected have personal stories and anecdotes to accompany them, relationships that make collecting important and meaningful. When his collection traveled nationally between 1998 and 2002, the event was an eye-opening experience for young collectors as well as older, established art institutions. Driskell has maintained meticulous records of his correspondence and exchanges with young artists, and he regarded the tour as yet another opportunity to educate a broad public as to the richness of African American history. Recently at a lecture at the Museum of Fine Arts, Houston, he shared with others the pleasure of surrounding oneself with art in a home that conveys meaning and history. Currently, the Driskell Center for African American Studies at the University of Maryland, College Park, is extending the study of art and connoisseurship to yet another generation. Because of his expertise as a collector and as an artist, Driskell was asked by President and Mrs. Clinton to search for a work by Henry O. Tanner as the first work by an African American artist to be included in the White House. Similarly, because of his expertise, he has been the curator who has helped to develop and shape the Cosby Collection of African American art since its inception.

The recent gift of the Paul R. Jones Collection of African American Art to the University of Delaware represents a major new chapter in the development of institutional "homes" of private

collections of African American art. Paul Jones, a businessman and political consultant, made the decision to give his collection of one thousand works to the university because of its commitment to the teaching of American art history. He explained, "I have wanted to find a way to keep the collection together so that it will have the greatest possible impact on artists, scholars, and students. For the last five years, I have been looking for the ideal home where the collection would be wanted and woven into the fabric of an institution, where it would be used for teaching and exhibitions."[51] As a condition of the gift, the University Gallery has agreed with Spelman College and Morehouse College in Atlanta to collaborate on exhibitions organized in conjunction with the Jones Collection. Jones states, "I wanted to weave art into teaching. I began lending . . . so I could feed the appetite of others. I wanted to stimulate people to collect African American art . . . I requested that the university collaborate with African American colleges. This collaboration will hopefully allow the university and black colleges to come to the table as equals."[52] Recently honored for his philanthropy with the James VanDerZee Award by the Brandywine Printmaking Workshop in Philadelphia, Jones has been collecting African American art for nearly forty years. Born in Bessemer, Alabama, Jones became aware of fine art while living in the Bronx and Washington, where he attended elementary and junior high school. His collection includes works by Charles White, Kofi Bailey, David Driskell, Elizabeth Catlett, Jacob Lawrence, and Romare Bearden, with particular strength in his holdings of works of black photographers such as P. H. Polk, Roy De Carava, and younger, less well-known photographers. In his early years as a collector, Jones became aware that African American art was "vastly under-represented in public collections." Jones deliberately identified a number of artists whose work he wanted to support, repeatedly offering his patronage to the younger emerging artists who rarely had gained gallery support. From his

early role as an art patron he developed enduring friendships. Rick Beard, curator of the Atlanta History Center, reflects on the intent of Jones's role as a collector and the impact of his recent gift: "Paul's intent is to mainstream this material, to get it into the canon of American art. What he's saying is that these people were important artists and they deserve to be looked at in the same context as other American artists. That argues for an institution like the University of Delaware that has a history of teaching and publishing with a focus on American art."[53] There is no argument that the collection of Paul Jones added to the cultural climate in Atlanta with his abundance of art. However, the addition of such a collection of African American art to a major non-black institution also indicates a growing awareness outside of the African American community of the importance of this body of work. The University of Delaware is planning to make the collection the centerpiece of its new Center for American Material Culture Studies. The Jones Collection joins an earlier gift of Inuit art from the Frederick and Lucy S. Herman Native American Art Collection. Amalia Amaki, African American artist and art historian, will serve as curator of the collection, coordinating the cataloguing and documentation of the works while completing a book on the history of the collection.

In a similar act of "mainstreaming" African American art collections, recently the Bank of America purchased the Hewitt Collection of African American Art as a gift for the Afro-American Cultural Center in Charlotte, North Carolina. The collection was developed by John and Vivian Hewitt during their many years in New York, two educators who were part of the cultural circles that defined black New York beginning in the 1950s. As a cousin of Eugene Grigsby, Vivian Hewitt was introduced to a number of artists, including Romare Bearden, soon after her arrival in New York from Atlanta with her husband. Similarly, John Hewitt's sister, Adele Glasgow, owner of Market Place Gallery in Harlem,

from the gallery's opening involved the couple in the many salons held at the gallery. Responding to a request by the artist Alvin Hollingsworth, the Hewitts began in the late 1970s to host art presentations in their homes for a number of African American artists, including Hale Woodruff, Ernie Crichlow, and Eugene Grigsby.[54] The Hewitts, never working as agents for the artists, saw this simply as another opportunity to support black artists who at the time had limited gallery representation and access to mainstream museum curators. The tradition of collectors hosting exhibitions in their home for African American artists continues today among black collectors throughout the country. Like Walter Evans, the Hewitts in their dedication to African American art expressed not only a passion for the arts, but a personal and purposeful support of their artist friends.

Despite the history of collecting African American art and the lengthy involvement of individuals in the preservation of the culture, there are still a number of issues that face the African American community regarding the promotion of collecting within the community. There needs to be more education in terms of what affluent African Americans comprehend as "good art." There needs to be more risk taking in terms of those who will support young, contemporary, edgy artists who may not be household names today, but whose talent will propel them into the larger art world and onto an international plane of recognition. When they reach that plane, they are often out of reach. We need to take advantage of the fact that as part of our community, these young artists are known to us, and we should be there to nurture and support them when they are just young artists. The African American community needs to look further into areas such as self-taught artists and craftspersons so that we have a greater sense of this tradition. We need to look carefully at the creative activity taking place throughout the African diaspora, including contemporary African art and the current art of the Caribbean. Finally, there

needs to be a network among collectors who can advise younger collectors regarding the highs and pitfalls of collecting. Books such as Halima Taha's *Collecting African American Art* are responses to this need. More forums need to be held in museums to guide novice collectors as to how best to use their financial resources and their time. Collectors need to learn the art of documenting their work and keeping records that indicate that personal relationship that they had with the artists: correspondence, photographs, videos, and other documentation.

The newest wave of collectors represents the younger generation. That generation includes outstanding individuals such as Grant Hill. Many of these young people have been afforded advantages in terms of position or career and have come to enjoy the depth of cultural richness that is part of the black experience. Oprah Winfrey, an active collector, utilizes her powerful position with the media to focus on the richness of black culture. She has featured the curator, educator, and artist David Driskell on her program and has referred frequently to the spiritual wealth that having art affords to her. Rush Arts Gallery in New York City, for example, is supported by the entrepreneur Russell Simmons and his brother, the artist Danny Simmons. The Simmons brothers, as both artists and collectors, have dedicated much of their personal energy and financial support to creating a series of programs focused on exhibition opportunities for emerging black artists.

Grant Hill personifies the scholar athlete as cultural champion. This concept hearkens back to Paul Robeson, who was an athlete but also so much more: a major conservator and collector, as it were, of the beauty of traditional black music. His recordings of traditional black song—spirituals and folk songs—enable us to hear today the rich heritage of African American music. In 1928 Robeson performed in a concert to create support for a Museum of African Art. Proceeds from the concert led to the purchase of

the Blondiau-Theatre Arts Collection of African Art that was deposited at the 135th Street Branch of the New York Public Library.[55]

With the encouragement of his family, Grant Hill has come to know the importance of preserving the rich heritage of his culture. I recently observed the young Mr. Hill at an event honoring his basketball coach and friend, Coach Krzyzewski. The event was to raise funds for the Emily Krzyzewski Family Life Center, a center established to honor Coach K's mother. There was a large silent auction with a number of sports memorabilia, and additionally two live auction items. What interested me most was one of the live auction items, a huge double portrait of Michael Jordan and Muhammad Ali, signed by both of these athlete icons. To me, this work was a piece of history and were I wealthy enough, I would have bid. The live auction for the photograph turned out to be just that, quite lively, and the bidding for the piece was intense. When all was said and done, however, the winning bidder was Grant Hill. He had purchased a major piece of African American history and at the same time he supported an important institution being developed by his former coach. In organizing this exhibition tour, Hill establishes a message that is sent out clearly to others who share his position of privilege. Like those before him, he collects not simply to adorn the walls of his home but to move the public and to make all of us more aware of the power and beauty of African American art. His generosity of spirit brings us these treasures to cherish. ■

NOTES

Epigraph. Manning Marable, "Race Identity, and Political Culture," in *Black Popular Culture*, ed. Gina Dent (New York: New Press, 1983), 302–3.

1. Sharon Patton, "A History of Collecting African American Art," in *Narratives of African American Art and Identity: The David C. Driskell Collection* (Rohnert Park, Calif.: Pomegranate Communications), 45.

2. Billie Burn, *Stirrin' the Pots on Daufuskie* (Spartanburg, S.C.: Reprint Company, for Billie Burn Books), 62.

3. Derrick Joshua Beard, *The Sankofa Collection [A Partial Selection of Items]* (Pasadena, Calif.: Curatorial Assistance, 2000).

4. John Beardsley and others, *The Quilts of Gee's Bend* (Atlanta: Tinwood, 2002), 67.

5. Moses Adams (grandson of Lettie North), interview by author, Houston, 12 August 2002.

6. Alice Mae Williams, interview by Alan Govenar, in *African American Frontiers: Slave Narratives and Oral Histories*, ed. Alan Govenar (Santa Barbara, Calif.: ABC-CLIO, 2000), 472.

7. Carole Merritt, *Homecoming: African American Family History in Georgia* (Atlanta: African American Family History Association, 1982).

8. John Ethan Hankins and Steven Maklansky, eds., *Raised to the Trade: Creole Building Arts of New Orleans* (New Orleans: New Orleans Museum of Art, 2002), 145.

9. Andrew Guy Jr., "Piece by Piece," *Texas: The Houston Chronicle Magazine*, 2 February 2003, 9.

10. Pamela Newkirk, *A Love No Less* (New York: Doubleday, 2003), 9.

11. Regenia Perry, "Cultural Identity in African-American Art, 1900–1950," in *Celebration and Vision: The Hewitt Collection of African-American Art*, ed. Todd D. Smith (Charlotte, N.C.: Bank of America, 1999), 8.

12. Julie McGee, "Collecting African American Art: Educating the Public through Private Means," unpublished paper delivered at the Art Institute of Chicago, 2002. McGee's note: "Tanner private correspondence, cited by Marcus Bruce."

13. Perry, "Cultural Identity in African-American Art," 8.

14. Perry, "Cultural Identity in African-American Art," 9.

15. McGee, "Collecting African American Art."

16. Steven Jones, telephone interview by author, 12 April 2003. See "A Keen Sense of the Artistic: African American Material Culture in 19th Century Philadelphia," *International Quarterly of African American Art* 12, no.2 (1995): 4–29.

17. Charles L. Blockson, "Bibliophiles and Collectors of African Americana" (web site, consulted 14 April 2003).

18. Deborah Willis, *Reflections in Black: A History of Black Photographers 1840 to the Present* (New York: W. W. Norton, 2000), 9.

19. Ibid., 14.

20. Ibid., 3.

21. VanDerZee would often include photographic elements such as angels, cherubs, and a figure of Christ in his mortuary images. Rodger C. Birt describes these images as a combination of Victorian and Edwardian visual traditions and avant-garde 1920s photomontage designs. See Rodger C. Birt, "A Life in American Photography," in *VanDerZee, Photographer, 1886–1983*, by Deborah Willis Braithwaite (New York: Harry N. Abrams, 1993), 16.

22. Howard Dodson and others, *The Black New Yorkers: The Schomburg Illustrated Chronology* (New York: John Wiley & Sons, 2000), 194.

23. Ibid., 195.

24. Ibid.

25. Richard J. Powell and Jock Reynolds, *To Conserve a Legacy: American Art from Historically Black Colleges and Universities* (Cambridge: MIT Press, 1999).

26. Mary Lou Hultgren and Jeanne Zeidler, "Things African Prove to Be the Favorite Theme: The African Collection at Hampton University," ART/*artifact* (New York: Center for African Art, 1988).

27. Powell and Reynolds, *To Conserve a Legacy*, 24.

28. James A. Porter, *Modern Negro Art* (New York: Dryden, 1947).

29. Powell and Reynolds, *To Conserve a Legacy*, 206.

30. Kevin Grogan, "Fisk University Galleries and Collections," in Powell and Reynolds, *To Conserve a Legacy*, 20.

31. Ibid., 21.

32. Alvia J. Wardlaw, "A Spiritual Libation: Promoting an African Heritage in the Black College," in *Black Art, Ancestral Legacy: The African Impulse in African American Art* (New York: Harry N. Abrams, 1989), 65.

33. John Biggers and Carroll Simms with John Edward Weems, *Black Art in Houston: The Texas Southern University Experience* (College Station: Texas A&M University Press, 1978).

34. Dr. Harry Robinson, director, and Phillip Collins, chief curator, African American Museum, Dallas, interviews by author, 18 April 2003.

35. John Biggers, *Ananse: The Web of Life in Africa* (Austin: University of Texas Press, 1962).

36. David C. Driskell, *The Other Side of Color: African American Art in the Collection of Camille O. and William H. Cosby, Jr.* (San Francisco: Pomegranate, 2001).

37. *African American Art: The Harmon and Harriet Kelley Collection* (Austin: University of Texas Press, 1994).

38. Jan Russell, "Collecting Their Culture," *Texas Monthly*, September 1996, 1.

39. Ibid.

40. Ibid.

41. Harriet Kelley, interview by author, April 2003.

42. Russell, "Collecting Their Culture," 2.

43. Andrea Barnwell, *The Walter O. Evans Collection of African American Art* (Seattle: University of Washington Press, 2000), 19.

44. Ibid.

45. At his lecture titled "Reflections on Collecting African American Art: Focusing on Jacob Lawrence," presented at the Twenty-Eighth Annual Ruth K. Shartle Symposium, "Over the Line: Jacob Lawrence in Context," at the Museum of Fine Arts, Houston, 8 November 2002, Dr. Evans shared photographs of his many salons hosting Rosa Parks, Gwendolyn Brooks, Jacob Lawrence, and Gwendolyn Knight Lawrence.

46. Barnwell, *The Walter O. Evans Collection*, 21.

47. Ibid., 24.

48. Juanita Marie Holland, *Narratives of African American Art and Identity: The David C. Driskell Collection* (San Francisco: Pomegranate), 12.

49. Ibid., 16.

50. Ibid., 16–17.

51. "Paul R. Jones Art Collection Has New Home on UD Campus," *[University of Delaware] Update*, 22 February 2002.

51. Ibid.

52. Ibid.

53. Smith, ed., *Celebration and Vision*, 4.

54. Dodson and others, *The Black New Yorkers*, 198.

The Genius of Romare Bearden

ELIZABETH ALEXANDER

It is difficult to imagine twentieth-century American art without Romare Bearden, and it is equally challenging to settle on a single topic when presented with the felicitous opportunity to write about his work. Do we choose a little-researched period in the artist's work, or in his life as a painter who was also a social worker, songwriter, traveler, intellectual? Or do we abandon scholarly methods and instead rhapsodize, exalt in the magnificent and meticulous scope of any given Bearden work? Do we think about the art in the context of New York City, Pittsburgh, Paris, St. Maarten, or Mecklenburg County, North Carolina? Do we focus on the medium of prints or consider also his early abstract oils? Dare we neglect the magnificent Bearden collage?

Grant Hill has wisely collected a dazzling group of Beardens that span the artist's career, from the early gouache paintings *Serenade* (1941) and *They That Are Delivered from the Noise of the Archers* (1942) to the great collages of the 1980s. Those early paintings give fascinating indications of what Bearden achieves later on. We see his proclivities as the master colorist he fully becomes in the collage form; his interest in the (black) figure seen in geometric components; and important Bearden icons such as the guitar. Viewers of this collection can begin to understand how a mature style develops by viewing these rarely seen early paintings. The 1979 collage in the collection, *Time for the Bass*, gives us Bearden in his exhaustive jazz mode. These works translate the energy, rhythm, and movement of jazz music into the flat form. This collection also shows us Bearden's urban and rural modes of Mecklenburg County and Harlem. Bearden's work dis-

plays a great, intimate understanding of those landscapes that outlines the movement of so many black people from South to North in the Great Migration.

The Grant Hill Collection gives an opportunity to see not only the span of Bearden's career but also a generous selection of his work in collage. For Bearden's art comes into its most mature form in collage, and it is not hyperbole to state that as a collagist he is without parallel. I want to focus on collage first by discussing the work itself but then by thinking about how the Bearden collage gives us a way to think about the complexities of African American identity. In that regard, we might look at Bearden as an important twentieth-century African American theorist as well as one of its most magnificent visual artists.

Bearden reconfigured collage through European cubism, African American quilting, and idioms of jazz and the blues. His subject matter has ranged from a retelling of *The Odyssey*, in vibrant blacks and blues, to scenes from the North Carolina of his early childhood. His iconography is magically commonplace: trains seen through doorways, roosters, doves, saxophones, trumpets, washtubs, clouds. Bearden moved through phases of abstract oils and cubist watercolors but found his fullest voice in the 1960s, when he began to work extensively in collage. His work combines any number of media, from newspaper and magazine pictures, to brightly colored paper, to fabric, watercolor, and thick black "Speedball" pens.

Everything you read and the stories people tell about Bearden say that he was a very clever man, analytical and dazzlingly well read, humble without being self-effacing, respectful, and aware of himself in relationship to myriad traditions. While writing a paper about him in college, I decided that I wanted to speak to him, found him in the New York City phone book, called him, and found him in, answering the phone, and willing to entertain my questions. By the end of the conversation he had sent me to

Sun Tzu's *The Art of War*, any stained glass windows I could find, and Earl "Fatha" Hines's music, so that I might better understand Bearden's own work. Bearden had digested a wide range of influences to arrive at the specificity of his vision.

Here is a quotation from Bearden, on his own identity: "I think of myself first as an American, and being an American means four things. One, being in the tradition of Emerson, Emily Dickinson, Melville, Walt Whitman. Second, you have to have the spirit of the whole Negroid tradition. The third tradition is the frontiersman, like Mark Twain and Bret Harte, and the fourth tradition is the Indian." The great W. E. B. Du Bois wrote these lines in 1903, in *The Souls of Black Folk*: "One ever feels his two-ness—an American, a Negro; two souls, two thoughts, two unreconciled strivings; two warring ideals in one dark body, whose dogged strength alone keeps it from being torn asunder." "One ever feels his two-ness" would become a veritable mantra to legions of students of blackness. Du Bois's image of an ineffably split African American consciousness, and of bifurcation as the major twentieth-century trope for African American consciousness, remains resonant today.

But over one hundred years later, the "two-ness" trope must be revised. I contend that if the African American intellectual consciousness is split, it is split multiply rather than doubly, and that that so-called fragmentation, arisen from the fundamental fragmentation of the Middle Passage, has become a source of our creative power. The complex coexistence of a spectrum of black identities in a single space—think of Bearden's own self-description above, for example—represents a particular strength and coherence of African American cultural production. Formal conflict is the locus of true innovation such as that which is evident in the twentieth-century African American tradition, from *Souls* back to Anna Julia Cooper's *A Voice from the South* to *Cane* (Jean Toomer), to *Invisible Man* (Ralph Ellison), to *Mumbo Jumbo*

(Ishmael Reed), to *The Bluest Eye* (Toni Morrison), among others. In order for Du Bois to make a space for his "type" on the literary continuum, that type being the twentieth-century heretofore unimagined African American intellectual who would write a book with the formal multiplicity and referentiality of *Souls*, he had to "make" a multiple self in the text at hand. In other words, the structural hybridity of the book *Souls* necessarily makes the written space in which the author can fully explore aspects of what I would call his "collaged" identity. And collage, as developed and employed by Bearden, is my model to describe the presentation of self-identities in African American literature and culture. Critics have used collage to talk about the literary works of modernist writers such as Joyce, Pound, and Eliot, as well as in Dadaist novels and various postmodern forms, but the Bearden collage offers a more necessarily historical—and culturally particular—context for twentieth-century African American literature and culture.

Collage lets us think about identity as a spoked wheel or gyroscope on which its aspects spin and recombine. Collage also allows us to see African American creative production as cohesive rather than schizophrenic. In other words, the disparate aspects of personalities and of influence that might seem contradictory can actually coexist in a single personality, or a single identity. When the process of cutting and pasting is visually evident—as it is in the cut and torn edges within Bearden's collages—yet obscured by the fact of the unified whole that the picture represents, the creative and constructive process itself is valorized as a crucial and *aesthetic* component of the path to artistic coherence, and, indeed, an avenue to understanding how "coherence" itself is evaluated.

Collage, in the flat medium as well as more abstractly in book form and as a metaphor for the creative process, is a continual cutting, pasting, and quoting of received information, much like jazz music, like the contemporary tradition of rapping, and in-

deed like the process of reclaiming African American history (or of any historiography). African American culture from the Middle Passage forward is of course broadly characterized by fragmentation and reassemblage, sustaining what can be saved of history while making something new. Collage constructs wholes from fragments in a continual, referential dialogue between the seemingly disparate shards of various pasts and the current moment of the work itself, as well as the future that the work might point toward. Ralph Ellison said, about Bearden:

> [Bearden] has sought here to reveal a world long hidden by the clichés of sociology and rendered cloudy by the distortions of newsprint and the false continuity imposed on our conception of Negro life by television and much documentary photography. Therefore, as he delighted us with the magic of design and teaches us the ambiguity of vision, Bearden insists that we see and that we see in depth and by the fresh light of the creative vision. Bearden knows that the true complexity of the slum dweller and the tenant farmer requires a release from the prison of our media-dulled perception and a reassembling in forms which would convey something of the depth and wonder of the Negro American's stubborn humanity.

And here, a quotation from Picasso on collage:

> If a piece of a newspaper can become a bottle, that gives us something to think about in connection with both newspapers and bottles, too. The displaced object has entered a universe for which it was not made and where it retains, in a measure, its strangeness. And this strangeness was what we wanted to make people think about because we were quite aware that our world was becoming very strange and not exactly reassuring.

Picasso's displaced "object" could be thought of as the African body, then the African American body in migration, and collage

as the process through which that "body" makes sense of itself in a hostile and unfamiliar environment.

Any discussion of the African American collage must include a discussion of the quilt. Quilts embody the simultaneous continuity and chaos that characterize African American history in all spheres. If African American creativity is always in some way grappling with African American history by trying to knit together the fragmentation that forms its core and the paradox of fragmentation as a center, quilting is a motif for a creative response to that history. Romare Bearden himself understands how quilting fits into African American social, creative, and visual history. He has represented the act of quilting in his work and his collages allude to strip weaving, quilts, and textiles. He also utilizes actual scraps of fabric. He has called his collage making "precisely what the ladies (at the quilting bee) were doing." The bits and pieces that make quilts as well as collages all refer to their uses and places in other lives; the life of the quilt is the aggregate of those pieces, and the work then becomes a referential discussion of both past and present at once.

West African, Mande-influenced strip weaving, in which narrow strips of cloth, sometimes as many as one hundred, were sewn together to make larger pieces of cloth or garments, was a crucial precursor to the African American quilt. The patterns that made their way into the African American tradition were the so-called "crazy quilt" patterns, seemingly irregular contrasts of color and line. These West African fabrics were collaged in the sense of being disparate pieces put together, though they do not have the same system of diverse referents as New World collages; once these textile traditions reached the Americas they arose of different material and historical circumstances, and the textile work, as with other arts and crafts, reflected those new circumstances. Still, the process of putting pieces together and the improvisational possibilities inherent in the contrast of colors and patterns

relate to the concept of collage. Strip weaving and quilting are not the same as cutting a pattern for a dress, where each piece is predetermined and the outcome of the whole can be anticipated. Rather, when strips of cloth are sewn together, like strips in a quilt, the creative process continues throughout that act, through the matching and setting of color to color and pattern to pattern.

Fon-influenced appliquéd textiles also found their way to the African American quilting tradition. Those African textiles set up intricate symbolist landscapes and told stories, strongly derivative of Egyptian hieroglyphics. African American story quilts, in particular Harriet Powers's story quilts executed between 1886 and 1898, blend the New World necessity of sewing bed covering with Old World information about textile work, in a New World manifestation of ancestral motifs and narrative impulses.[1]

An African American quilt might be made from pieces of blanket wool, worn cotton from an apron, a soft piece of calico from a fourth-hand dress. The materials of the new place could nonetheless reflect the patterns of an ancestral heritage, just as slaves made instruments from whatever was at hand—washtubs, broom handles, even their own bodies in hambone and spoons. A washboard could make sounds and music but was also, or had been, an instrument of work, a historical referent of the condition of the creator. The object had its contemporary life and meaning as well as its ulterior "lives," all in the same site. If nothing else was available, when even the body was not legally one's own, the body nonetheless could become a site for creative assemblage.

Composite visual works are ancient and cross-cultural. In the twelfth century Japanese calligraphed poetry was made of cut and pasted pieces of delicate paper. Thirteenth-century Persian artists cut leather into flowers for bookbinding. In the early seventeenth century and quite probably earlier Mexican feather mosaic pictures were made, as were, in the same century in Europe, mosaic pictures from such earthly objects as beetles and corn

kernels. Eighteenth-century European collages were made from butterfly wings, and in mid-century the still-familiar British tradition of Valentines commenced. According to the art historian Herta Wescher, there is "nothing very new about the essential idea of collage, of bringing into association unrelated images and objects to form a different expressive identity." Eddie Wolfram observes, "besides their functional reality, some mundane objects have always held the potential of an 'inner,' more magical reality that is connected with man's wonder about the nature of existence and his own destiny."

Collage, per se, entered the art history lexicon in the early part of the twentieth century as an outgrowth of cubism, and cubism of course developed as its practitioners were becoming familiar with and consequently inspired by different kinds of African art. Gregory Ulmer calls collage "the single most revolutionary formal innovation in artistic representation to occur" in the twentieth century, and states that the innovation broke with traditional realism in its interplay between what Bearden called "mosaic-like joinings" and the unified image viewed from a greater distance. Wescher insists that twentieth-century collage was scarcely influenced by these earlier developments of "craftsmen, folk artists, and amateurs," which seems dubious, but certainly this was the first time that collage was employed by creative artists as the outgrowth of a specific artistic movement.

The word "collage" comes from the French "coller," meaning to paste, stick, or glue. Claude Lévi-Strauss would play with that root when in *The Savage Mind* he used the term "bricoleur," for one who made do with whatever was at hand, "with a set of tools and materials which is always finite and is also heterogeneous." The first collages recognized as such were Pablo Picasso's *Still Life with Chair Caning* and Georges Braque's *Fruit Dish*, both made in 1912. There is some dispute over who made the first of what we now call collages, Picasso or Braque; both claimed credit, and

Picasso may have predated *Still Life* to place himself first. But at this point in the cubist movement both artists had similar aims.

In cubism, painters attempted to show their subjects from as many sides or perspectives as possible at the same time. This concept revolutionized the world of possibilities in modern art by introducing the concept of simultaneity and a departure from the flat, literal surface. Collage juxtaposed seemingly disparate elements into a new context and a new whole. Braque said that in collage he could separate color from form, thus allowing both to "emerge in their own right," or exist simultaneously, together and apart.

The displaced "object" that Picasso mentions in the above quotation is, in African American terms, first and foremost the displaced African body. There is also a "displaced," or, to riff on Carter G. Woodson, "mis-placed," galaxy of cultural and historical references that the African American cultural worker draws upon. Historical distortions are deliberate and not at all haphazard; we are displaced in that we were taken from Africa, and we are misplaced in that we have been put in a place, both literally and figuratively, that does not acknowledge the full complex dimensions of our existence. Cultural workers must then continually strive to create, validate, and keep in circulation written evidence, traces, of actual cultural existence. The quilt or collage creates something new that is simultaneously what it was and what it might be, because of its referentiality. The finished product is always a reflected breakdown of selections, the mechanics of choosing. The act of making is inherent in the finished thing itself.

When Bearden cuts colored paper rather than representational newspaper and magazine images, the shapes he makes from the paper become repeated motifs, his ritual shapes and images that continually call attention to a depth and a life behind the canvas itself. Bearden said: "In most instances in creating a picture, I use many disparate elements to form either a figure, or part of a

background. I build my faces, for example, from parts of African masks, animal eyes, marbles, mossy vegetation, [and corn]. . . . I then have my small original works enlarged so the mosaic-like joinings will not be so apparent, after which I finish the larger painting. I have found when some detail, such as a hand or eye, is taken out of its original context and is fractured and integrated into a different space and form configuration it acquires a plastic quality it did not have in the photograph."

Bearden first ventured into collage explicitly in 1951 with *Untitled: Duke [Ellington] and Billy [Strayhorn]*, and he experimented with Egyptian hieroglyphics in a "Hierographs" show in the 1940s. His watercolors from the 1940s and early 1950s are characterized by pointed shapes and blocks or patches of color separated by heavy black lines, an element that would recur in later collages. It was not until the 1960s that Bearden was fully involved in collage as his primary art form. But the crucial difference in collage is the concept of overlapping; that separated spaces and blocks of color do not represent an integration of disparate segments in the same way that overlap and consequent recombination underpin the very concept of collage, especially in the sense that I am using it to talk about identity formation, because I am arguing for an African American identity that is not segmented but rather a curious whole. Collage becomes a way to remember, and the process of remembering and refiguring, whether literal or metaphorical, is inherent in the African American literary enterprise and finds a vehicle in the act of collage. A look at the process of piecing together in Bearden's work will provide a bridge to understanding the same process at work later in African American written works.

Untitled: Duke and Billy, which appears to be the earliest of Bearden's published collages, is a whimsical postcard. A dutiful Billy Strayhorn and a jaunty Duke Ellington stroll by a Paris bookstand in a snapshot on the left side of the plane. On the right,

Bearden has made ink line drawings of cliché Paris postcard scenes: the Eiffel Tower reaching to the clouds, a bridge over the Seine, a *jeune homme* in ankle-pants and striped sailor shirt. The background is green, and red, white, and blue stripes to suggest the French flag govern the frame in titled rectangles. "Duke and Billy" is handwritten in red and blue underneath the photograph. What makes this collage most interesting is that Bearden has pasted cut sections of photo contact sheets of Ellington and Strayhorn in what looks like a Parisian train station. The contact sheet represents time in the collage—the sense of a whirlwind trip as exemplified in the rapid shifts between the frames—as well as an intimacy: Was Bearden there? Did he take the pictures? They are not posed portraits but rather snapshots; how did he come upon them? Bearden leaves off the last names of his subjects to suggest that either he is intimate with the subjects or we should be intimate with them, "Duke" and "Billy" to all. The public France of the postcard moves quickly to the intimate France, and the larger cultural juxtaposition is one of these two black American musical greats bringing their black jazz to Europe. This minor collage illustrates how referentiality embedded in the objects juxtaposed on the page opens up the fields of meaning in the work itself.

In Bearden's collages, you see the simultaneous referentiality—the "past life" of the cut or torn fragment—as well as the contemporary moment or whole that these reintegrated fragments create. Bearden's collage *The Block I* (1971) is a long, horizontal rectangle, setting up a sense of the forward movement of narrative from the start. Though Palmer Hayden and Archibald Motley are the artistic parents of the African American street scene, Bearden was the first to go behind the façade of the black inside his subject's homes and lives. For the buildings he has used plain brown papers, bricks he has painted himself, and what looks to be brick-patterned contact paper, reminiscent of the wood-grain paper used

by Picasso in those first collages. He has "cut" into the buildings not solely in the regular spaces where windows would be but rather at random spots, as though cutting through the brick. In this way the viewer feels less like a peeping Tom and rather like a privileged observer placed squarely in the middle of life lived. The irregularity of the cuts adds to the element of spontaneity and therefore "authenticity." Yet the artist also makes a viewer aware of this status of invasion, of looking in without having asked permission. Additionally, because we do not see into every room, the viewer is aware that choices have been made of what to reveal and what to keep private. The grave boy looking out might be asking "Who are you?" as the viewer asks the same question. The angels burst from the brick at the top of the work, making us aware of the constructed frame that defines and sometimes constricts a community as well as the spiritual necessity of imagining movement beyond those boundaries. Those angels make me think of Robert Hayden's great poem, "Summertime and the Living . . .," just as the episodic urban quality of *The Block* recalls Hayden's "Elegies for Paradise Valley." In "Summertime," he writes:

> But summer was, they said, the poor folks' time
> of year. And he remembers
> how they would sit on broken steps amid
> The fevered tossings of the duck, the dark,
> wafting hearsay with funeral parlor fans
> or making evenings solemn by
> their quietness. Feels their Mosaic eyes
> upon him . . .
> Oh, summer summer summertime—
> Then grim street preachers shook
> their tambourines and Bibles in the face
> of tolerant wickedness:
> then Elks parades and big splendiferous

Jack Johnson in his diamond limousine
set the ghetto burgeoning
with fantasies
of Ethiopia spreading her gorgeous wings.

In the Grant Hill Collection, we see a similar scene in *The Street* (watercolor and collage on board, 1985). The sense of a public black life and the private life beyond is made clear. The haunting black faces cut out from other places find themselves at home on this street. Yet their eyes speak of elsewhere, referring again, perhaps, to the Great Migration that was part of Bearden's own experience and that he understood as emblematic of black people in this country as they have moved and reassembled from one country to another, one region to another, even one block to another, adapting and evolving with each geographic shift.

Bearden's interiors also give us a sense of the intimacy with which he knew and saw black life, and his use of collage adds dimension to that sense of intimacy. In *Morning Gingham* (1985) two women start their day, one bathing and the other preparing water or food. They occupy the same space, faced in opposite directions, each performing her own ablutions, distinct yet together. The gingham in the collage is actual fabric, which serves both to represent a woman's skirt and a window curtain, but also to allude to a culture where nothing is wasted, where materials are recycled, and where stories are embedded in objects or materials. The recent Whitney Museum exhibition "The Quilts of Gee's Bend" magnificently showcases women who work together intimately—so in a sense this is collective or communal work—but their individual voices and aesthetics are also blazingly clear. The so-called Negro spirituals came from a collective context and collective authorship, yet they made space for the solo voice to be heard, individuality out of community.

You don't have to believe in magic to believe that objects carry

something from one person to another. Think of the old wedding tradition that a bride should wear something old, something new, something borrowed, and something blue. The "something borrowed" is meant to bring good luck and blessings to the bride from the person who first wore the brooch or carried the handkerchief. Few would dare break with such tradition. So it isn't a leap to understand that the bits of cloth that came from garments someone actually wore bring a bit of that person with them. To translate this to Bearden's artistic practice, as one imagines that many of these previous owners were unknown to him, he is bringing something of the actual spirits of black people into his work in a way that paint alone could never do. In the Grant Hill Collection we see this especially in *Morning Charlotte* (1985) and *The Evening Guitar* (1987). For what is Du Bois's double consciousness but the sense that we are scrutinized even as we make private space, that we are imagined even as we imagine ourselves? Bearden understood that paradox profoundly, and he managed the feat of making it visibly manifest in his collaged work. He also gave us a world of its own integrity, one that could be spectated, if you will, at the same time as it enjoyed the free play of imagination and self-invention, and, most importantly, that managed to convey profound intimacy. In this collection Bearden's genius is placed in context of a long and fruitful career. ∎

NOTE

1. John Michael Vlach, *The Afro-American Tradition in Decorative Arts* (Cleveland: Cleveland Museum of Art, 1978; repr. Athens: University of Georgia Press, 1990), 44–54.

Elizabeth Catlett: Making What You Know Best

BEVERLY GUY-SHEFTALL

Art is, and always has been, an expression of the historic conditions of people and should be a part of humanity's cultural wealth. Because I am a woman and know how a woman feels in body and in mind, I sculpt, draw, and print women. . . . I think there is a need to express something about the working-class Black woman and that's what I do. Art can't be the exclusive domain of the elect. It has to belong to everyone. . . . Artists should work to the end that love, peace, justice, and equal opportunity prevail all over the world.

—ELIZABETH CATLETT

One is immediately struck by the abundance and power of female images in Grant Hill's important collection of African American art. From Romare Bearden's *Mother and Child, Morning Gingham*, and *The Evening Guitar*, to Malcolm Brown's *Sophisticated Lady* and *Innocence*, we are compelled to take notice of the woman-centeredness of Hill's collection, whether the artists are male or female. It is tempting to assert that this extraordinary young man was intentional in his acquisition of powerful images of women as a way of celebrating the dignity, beauty, hard work, heroism, and complexity of African American women who have been undervalued and stereotyped in this culture. It is also the case that Black women artists have not received the attention they deserve, so that Hill's appreciation of the compelling sculpture and prints (lithographs) of Elizabeth Catlett, one of the most extraordinary American artists of the twentieth century, compels us to take notice. The art historian and critic Freida High Tesfagiorgis, in a ground-breaking essay on Black women artists, marks the importance of perhaps the most celebrated of Catlett's images of Black women, the series "The Negro Woman" (lithographs, 1946–47), which was later renamed "The Black Woman Speaks": "a landmark in the pictorial representation of Black women for it liberated them from their objectified status in the backgrounds and shadows of white subjects in the work of white artists, and from the roles of mother, wife, sister, other in the work of Black male artists."[1]

The art historian Samella Lewis begins her important study of Elizabeth Catlett, whose grandparents were slaves, with these

simple words: "This is a complex person—and a profound art."[2] The writer and art collector Maya Angelou is even more eloquent: "She reads our dreams and fashions them in sculpture, in paintings, in drawings, and words. She boldly uses all media to make public the best of our most private selves."[3] Born in Washington in 1915, Catlett recalls that she wanted to be an artist while she was still in elementary school and that her Dunbar High School teacher, Haley Douglas (a descendant of Frederick Douglass), was influential in her much later development as a sculptor: "What I remember most—and, I guess, when my creativity really began to work—was when we had to carve a bar of soap. I tried carving an elephant. At first I was just timidly chipping off the edges. And then I went home and I remember thinking about it when I was going to sleep, and suddenly I realized just how that little elephant ought to be carved. I went back to school the next day and did it, and I was very pleased with the result. I must have been thirteen at the time, and I still work that way today. If I'm working on something, when I go to bed, I start thinking about it, and I get a direction and a solution."[4]

It was Catlett's matriculation at Howard University (1931–35), which she selected because of its art department (the first of its kind at a historically Black college), that would be the pivotal influence in her development as an artist. At the age of eighty-eight, she continues to produce art and is now celebrated around the world for her accomplishments as well as her passionate commitment to social justice and social change, especially for African Americans and other oppressed peoples. While at Howard she came in contact with Black artists for the first time and studied with extraordinary professors—James Herring, James Porter, James Wells, and Lois Mailou Jones. Majoring in painting, she was introduced to the revolutionary Mexican muralists Diego Rivera, Jose Clemente Orozco, and David Alfaro Siqueiros, and while a student she also experienced a political awakening as she

became more knowledgeable about the plight of poor and oppressed people. Her activism propelled her to "stand in front of the Supreme Court building with a hangman's noose around her neck as part of an organized protest against the existing practice of lynching."[5] Political themes such as lynching and later civil rights and Black nationalism would be prominent in such familiar works as *And a Special Fear for My Loved Ones* (linocut, 1946–47), *Civil Rights Congress* (linocut, 1950), *Watts/Detroit/Washington/Newark* (linocut, 1970), *Black Is Beautiful* (lithograph, 1970), *Malcolm X Speaks for Us* (linocut, 1969), *Black Unity* (mahogany, 1968), *Political Prisoner* (cedar, 1971), *The Protester* (bronze, 1981), *Homage to the Panthers* (linocut, 1970), and *Homage to My Young Black Sisters* (cedar, 1968), a celebration of women of the Black Power movement and one of her best-known works.

After teaching art in the public schools of Durham, North Carolina, Catlett left for the University of Iowa, where she became the first student to earn an M.F.A. degree (in sculpture, 1940). While a graduate student there, she sculpted *Mother and Child* in limestone, which won the first prize for sculpture at the Negro Exposition in Chicago in 1940. Later she studied ceramics at the Art Institute of Chicago and joined the faculty at historically Black Dillard University in New Orleans, where she taught painting and sculpture from 1940 to 1942. In 1945 she was the recipient of a fellowship from the Julius Rosenwald Foundation, which would allow her to complete a series of prints, paintings, and sculpture on the oppression, resistance, and achievements of African American women. The series of fifteen linoleum cuts was collectively entitled "The Negro Woman" (1946–47). Grant Hill's *Domestic Worker* (lithograph, 1946), produced around the same time, evokes the struggles of hard-working, tired Black women who labor without adequate compensation but who manage to survive the indignities of racial, class, and gender oppression.

Catlett's journey to Mexico for the completion of this ambi-

tious project was to have a transformative impact on her career as an artist and activist, for it was here that she came into close contact with Mexican artists in solidarity with struggles against social, economic, and political oppression. After working with a group of influential printmakers at the Taller de Grafica Popular (Popular Graphic Arts Workshop) in 1946, she decided to live in Mexico and later joined and chaired the sculpture department at the National School of Fine Arts, National Autonomous University of Mexico (1958–76), becoming its first woman professor and sculptor. A year later she established permanent residence in Mexico and married her fellow artist Francisco Mora, whom she had met at the Taller; in 1962 she would become a Mexican citizen after being harassed by the federal government for her political views and even denied entry into the United States for allegedly being an "undesirable alien." After a ten-year hiatus, she was finally given a visa to enter the United States in 1971, enabling her to attend a solo exhibition of her own work at the Studio Museum in Harlem. Having been greatly influenced by the progressive politics of Mexican artists, she executed prints in which the primary subjects were women and children, workers, freedom fighters, and historical figures. The greatest impact of these works was "their social commitment, direct engagement with the experiences of ordinary people, deliberately accessible style, and choice of medium."[6]

The sculpture in Hill's collection—whether in stone, bronze, or onyx—is representative of the body of Catlett's magnificent sculptural art, which routinely and proudly focuses on the female figure, especially Black women, and the image of mother and child. *Standing Mother and Child* (bronze, 1978), *Mother and Child* (bronze, 1977), and *Mother and Child* (onyx, 2001) evoke memories of Catlett's master's thesis project, the limestone *Mother and Child* (1940) for which she won the first prize at the Negro Exposition. In her thesis statement, "Sculpture in Stone: Negro Mother

and Child," Catlett explained her interest in the mother and child figure, which she never abandoned: "The implications of motherhood, especially Negro motherhood, are quite important to me, as I am a Negro as well as a woman."[7] Many years later, she explained why she continues to explore this theme: "Because I am a woman and know how a woman feels in body and mind I sculpt, draw, and print women, generally black women. Many of my sculptures and prints deal with maternity, for I am a mother and a grandmother."[8] The Catlett scholar Melanie Herzog offers her own explanation as well: "She saw this theme as one in which blackness and femaleness intersect. That she grew up in a household where her mother and maternal grandmother were primary presences greatly influenced her consciousness of the maternal as central to female experience. Her mother-and-child images speak of a protective love that is simultaneously tender and fierce, of intergenerational continuity, and of the determination of strong women to hold their families together."[9] Catlett's own description of her creative process involves the use of models and close observation, but perhaps more importantly, the use of her own body: "I take the position that I want to do. It's feeling more visual when I'm working out an idea. So let's say it's a model sitting, leaning on an elbow. I'll sit like that, and I'll feel where the stress and tensions are. . . . I use my own body in working. When I am bathing or dressing, I see and feel how my body looks and moves. I never do sculpture from a nude model *Mostly I watch women*" (my emphasis).[10] Hill's collection also includes *Standing Woman* (bronze, 1987), *Reclining Woman* (stone, 2001), *Star Gazer* (bronze, 1997), and *Woman's Torso* (bronze, 1998), as well as portrait heads—*Cabeza Cantando* [Singing Head] (bronze,1960), *Glory* (bronze, 1981), and *Fluted Head* (bronze, 1997)—which capture, as always, the power and beauty of the Black female form. The art historian Richard Powell eloquently captures the transgressive nature of Catlett's portrayals of beauti-

ful Black women who are the antithesis of Eurocentric conceptions of beauty: "In prints created as early as 1946, Catlett raised aspects of Black facial physiognomy—dark skins, coarse and curly hair, broad noses, and full lips—to unprecedented heights of aesthetic contemplation and veneration. Simultaneously, her images of women—as workers, social activists, creative individuals, scholars and intellectuals, and, of course, as mothers—stood in sharp contrast to the often one-dimensional representations of women created by many visual artists."[11] These Catlett prints also reflect the influence of African art, especially West African masks, which we have come to associate with the highly celebrated art she has been producing for over sixty years. Catlett explains her lifelong affinity with her ancestral home: "I look for the relationship between African art which I cannot live without and the relation of that to black people. And I see in their faces and bodies African sculpture. And it's something I've been living with all my life."[12] Hill's collection of Catlett graphics are mostly from the series "For My People" (1992), commissioned by the Limited Editions Club to celebrate Margaret Walker's epic poem "For My People," her master's thesis in creative writing at the University of Iowa.[13] Catlett's long-standing friendship with Walker began while they were roommates (they were unable to live on campus because of segregation) at the University of Iowa pursuing graduate study. This limited-edition portfolio, illustrated in collaboration with the celebrated Black woman writer Walker, helps to immortalize Walker's famous poem. The prints which accompany the text of the poem explore themes that are reminiscent of the art Catlett has produced since the beginning of her career, including her first solo exhibition, "Paintings, Sculptures and Prints of the Negro Woman," which opened at Barnett-Aden Gallery in 1947 in Washington. One of the prints, *Singing Their Songs*, recalls the Black women workers in the 1946–47 linocut series, especially *I*

Am a Negro Woman, as well as Catlett's well-known linocuts *Share-cropper* (1968) and *The Survivor* (1983).

Elizabeth Catlett is certainly the most prolific, well-known, politically radical and socially engaged African American woman artist of our time. She is still "making what she knows best" in her home in Cuernavaca, Mexico, as one of our most revered elders and warrior women.[14] Passionate still about producing the "people's art," especially for Black people, she leaves as perhaps her most important legacy to all of us her uncompromising celebration of African American women: "Black women have been cast in the role of carrying on the survival of black people through their position as mothers and wives, protecting and educating and stimulating children and black men. We can learn from black women. They have had to struggle for centuries. I feel that we have so much to express and that we should demand to be heard and demand to be seen because we know and feel and can express so much, contribute so much aesthetically."[15]

Grant Hill's art collection is also a celebration of Black women from whom, we presume, he has also learned a great deal. What we see in the faces and bodies of women depicted by Elizabeth Catlett, Romare Bearden, John Biggers, Malcolm Brown, Hughie Lee-Smith, and Phoebe Beasley will remain in our hearts and souls forever. ∎

NOTES

Epigraph. Samella Lewis, *The Art of Elizabeth Catlett* (Claremont, Calif.: Hancraft Studios, 1984), the first monograph on Catlett; Lewis was a student of Catlett at Dillard University in the early 1940s when she chaired the Department of Art. A second monograph, Melanie Anne Herzog's *Elizabeth Catlett: An American Artist in Mexico* (Seattle: University of Washington Press, 2000), is an important contribution to the scholarship on Catlett. This essay's title was inspired by Catlett's painting professor at the University of Iowa, Grant Wood, who advised her to "make what you know best."

1. Freida High Tesfagiorgis, "Afrofemcentrism and Its Fruition in the Art of Elizabeth Catlett and Faith Ringgold," *Sage: A Scholarly Journal on Black Women* 4, no. 1 (spring 1987): 28.

2. Ibid., 1.

3. Lucinda H.Gedeon, ed. *Elizabeth Catlett Sculpture: A Fifty-Year Retrospective* (Purchase, N.Y.: Neuberger Museum of Art, State University of New York, 1998), 8.

4. Ibid.

5. Lewis, *The Art of Elizabeth Catlett*, 11.

6. Herzog, *Elizabeth Catlett*, 5.

7. Ibid., 21.

8. Ibid., 23.

9. Ibid.

10. Ibid., 35.

11. Richard J. Powell, "Face to Face: Elizabeth Catlett's Graphic Work," in *Elizabeth Catlett: Works on Paper, 1944–1992*, ed. Jeanne Zeidler (Hampton, Va.: Hampton University Museum, 1993), 49.

12. Ibid., 42.

13. See Margaret Walker, *For My People* (New Haven: Yale University Press, 1942).

14. See my essay, "Warrior Women: Art as Resistance," in *Bearing Witness: Contemporary Works by African American Women Artists* (Atlanta: Spelman Museum of Fine Art and Rizzoli International, 1996), 39–46.

15. James V. Hatch and Leo Hamalian, eds., *Artist and Influence* 11 (1991): 14.

OTHER SOURCES

Thalia Gouma-Peterson, "Elizabeth Catlett: The Power of Human Feeling and of Art," *Woman's Journal* 4 (spring–summer 1983): 48–56.

Juan Mora, *E. C.: The Work of Elizabeth Catlett*. New York: Third World Newsreel, 1978 (documentary film).

Carolyn Shuttlesworth, ed., *Three Generations of African American Women Sculptors: A Study in Paradox*. Philadelphia: Afro-American Historical and Cultural Museum, 1996.

ROMARE BEARDEN

Serenade

GOUACHE AND CASEIN ON KRAFT PAPER

30 x 47 inches | 1941

In this sensitive work, the strength of two individuals, a black man and woman, is set aside momentarily to create an intimate exchange. The gentleman is about to play or has just finished a tune on his guitar especially for the young woman. She looks off to the side, not willing yet to speak to him, her arms guarding her body and her heart. He looks off into the distance as if asking himself what else he can do to win the heart of this young lady, because she does not seem to be swayed. Behind them, the work of the fields, the picking of cotton, goes on as if all others are oblivious to this human vignette of love attempting to spring forth. In the background loom great mountains, silent witnesses to the serenade. The scroll work at the neck and the wrists of the young lady suggest a daintiness, a fragility that is not readily apparent in her face, while the man is depicted as a sturdy sort, simply clad, but holding beneath his arm the guitar that symbolizes another dimension of his character. The African profiles of the figures indicate Bearden's interest in fusing African imagery with the African American experience. The background seems deliberately simple and monumental.

GRANT HILL: In this work Bearden really captures that moment between a courting couple when the man is trying to be impressive and the woman is just not going for it. The man seems to be intent on impressing the young lady, ready to play her a lively tune. She doesn't seem that interested at the moment, but somehow I think his determination is going to win her over. This is a timeless picture, because the ritual still continues.

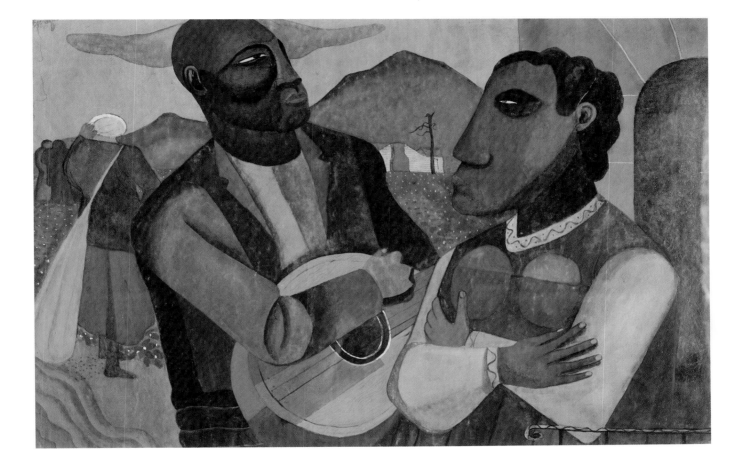

ROMARE BEARDEN

They That Are Delivered
from the Noise of the Archers

GOUACHE AND CASEIN ON PAPER

33 x 46 inches | 1942

This early painting prefigures Bearden's future approach to style. The enigmatic painting projects some of the artist's major stylistic characteristics that will remain with him even after he begins to create collage. The use of broadly geometricized features is also evident in the face of the man in the rearground, whose image closely resembles that of Chokwe figures from Central Africa. The woman standing with her arm held up also closely resembles in her facial features Central African sculpture. That Bearden had been looking hard at African art is no coincidence. After the Harlem Renaissance there was a serious interest in things African among African American painters. The angular dynamics of the painting also yield a body of energy that seems to move upward from the center of the group. In studying this work, one wonders whether this scene is about courtship, the love between two young people being rejected by the girl's parents. The central figure in the scene appears to be the individual of authority in this human drama, while the young man bearing a flower appears to be in pursuit of the hand of the young lady.

GRANT HILL: This is a mysterious painting but I like the energy in the gathered crowd. The sense of ritual that Bearden emphasizes in the work is very interesting. The young man seems to be gathering up all of his courage to present a flower to the young girl, only to be halted by the elders. This is a beautiful piece.

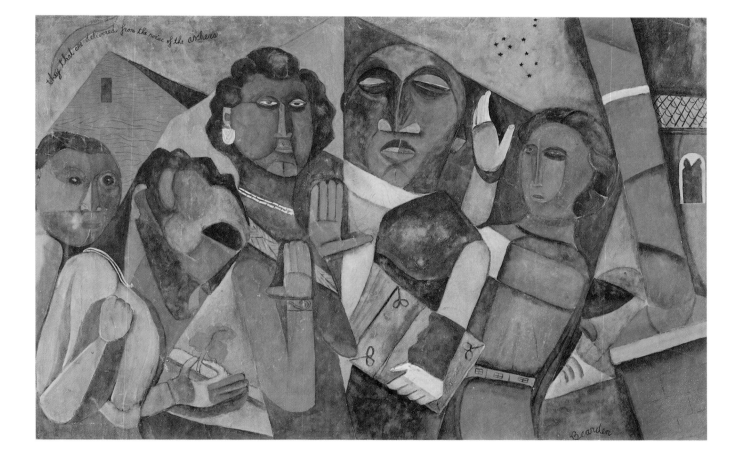

ROMARE BEARDEN

Number 9

OIL ON RICE PAPER ON CANVAS

44⅛ x 56 inches | 1960

This very experimental work shows Bearden's open-ended exploration of materials and color and technique. By making the rice paper adhere to the canvas, the artist acquires a stained color density that would not have been achieved by simply using the rice paper alone. The segment of blue in the upper-left-hand corner gives way to rust and brown tones across the surface of the painting. The work is instructive in its indication of Bearden's ability to work broadly and completely without representational subject matter. The formality of the work in its meshing together of various zones indicates an artist of great experience who is unafraid of approaching new techniques and masters his own experimentation with a sure hand.

GRANT HILL: There is a great deal of abstract energy in this work, and I like the way the artist is limiting himself to muted and neutral tones. It is as if he is setting up a visual challenge for himself with all of these bars and wedges of color. The pieces of rice paper that are brought together in collage form make a segmented puzzle on the surface of the canvas.

ROMARE BEARDEN

Seed Time

COLLAGE ON BOARD

36 x 48 inches | 1969

Bearden's technique in this work of laying down a field of muted tones, grays, and beiges, similar to those from a photographic negative, yields a time-bending quality to the image. The figures in the scene seem fused with the soil, as they work in the fields. The man in the left portion of the picture is the dominant, symbolic force of the work. He stands with his large hands open, holding in his left hand the precious seeds to be planted. Shown in profile, he has the same serious presence as a figure from antiquity, with the eyes of Egypt or Mesopotamia looking out into the future. Bearden deliberately softens the other features in the farmer's face, blurring them into the background like the other gray areas of the composition. The hint of color in his skin is limited to that area just beneath the eye, so that the viewer's own eyes return to the farmer's unblinking gaze. His gaze is totally fused with the blue of the sky around him, as the white of his eye has itself become blue, underscoring the otherworldly quality of his presence. The farmer seems to sense that this time is very impor-

tant—that it takes a great deal of work from everyone around, and the blessing of good weather, to enable his family to bring in a crop that will both feed them and keep them out of the pit of debt. But the gamble of life's process seems to bear into his visage, while others around him are busy in preparation. In contrast, the man at the right seems completely engrossed in the task before him. Ready to get to work, he leans over the mule, placing a harness on the animal as he prepares for the two of them to go out to the fields and till the soil. The mule, wearing his blinders, looks on in passive recognition of the task before him. The two women seem to be walking toward the field in bright conversation, able to be outdoors once again, having been inside their homes during the gray days of winter. The knowing and spare use of the color red in this work suggests how the day would have looked in reality, with the red of a bandana at the farmer's neck, the red headband of the farmer attending to the mule, and the red hem of the dress of one of the women talking.

GRANT HILL: The role of the farmer here is paramount. Bearden seems interested in recalling those times when black families were completely reliant upon their own life skills—the most basic ones—to survive. Farms like these were the mainstay of life in the South, with many black men and women working tirelessly as sharecroppers and getting very little in return for their endless work. How many of us in today's society could successfully run a farm?

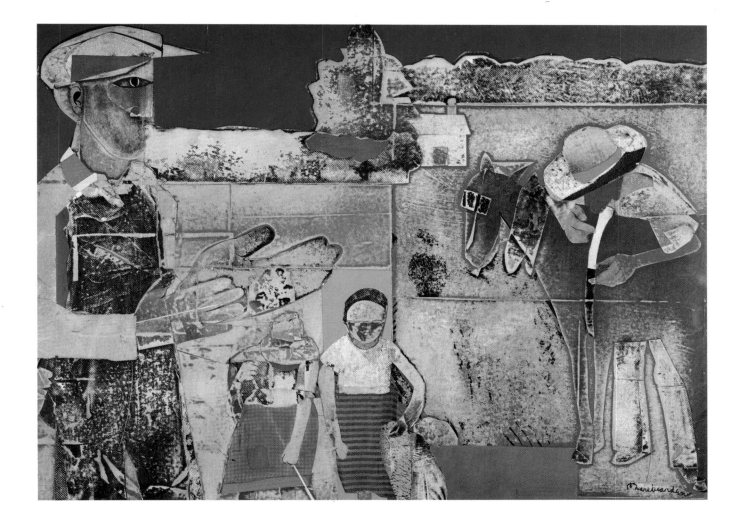

House

COLLAGE ON BOARD

22 x 16 inches | 1970

In this work a man wearing a hat sits on a bench in front of a house with a woman seeming to eat lunch from a brown paper bag. In the background, another woman, so pale she is almost a mirage, walks down the street. She appears, on close inspection, to be Janus-faced, as is the couple seated on the bench. The house in the background appears to be part of an urban or suburban setting, indicated by the gray sidewalk and driveway. The lone brick chimney juts upward into a cloudless steel blue sky. The application of gauzelike color to the board creates an illusory quality within the scene.

GRANT HILL: What is interesting to me about this work is the way in which Bearden can give the figure of the man such authority simply by giving him that brim hat with its red band; it stands out against everything much more than the women do and says a great deal about the relationship of men and women as it is often developed within households. I think that this work is more about the household, the relationship between people in the house rather than the house itself.

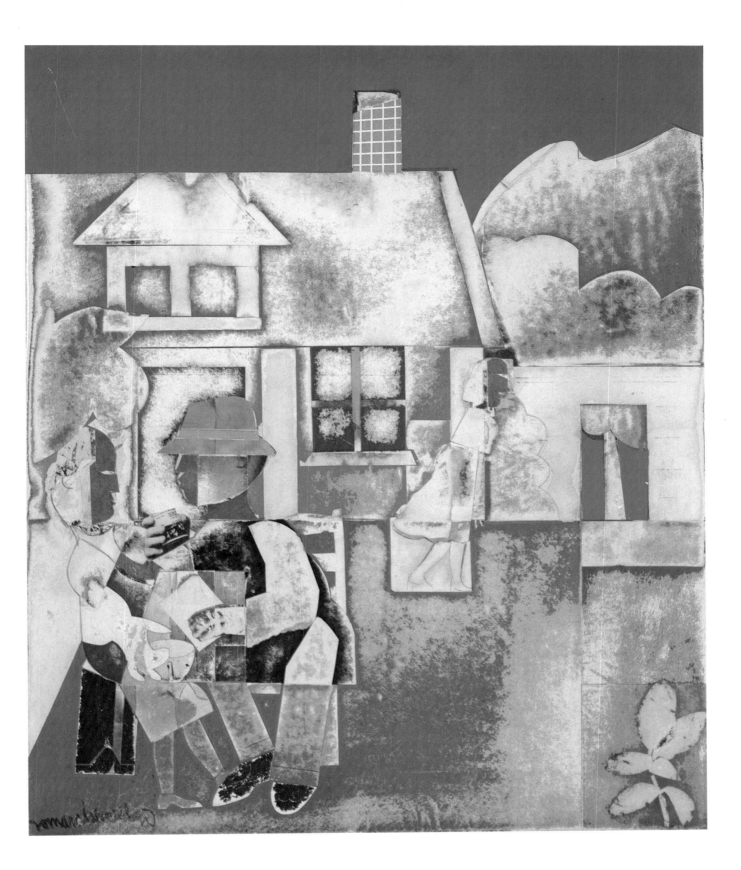

ROMARE BEARDEN

Cotton Field / Basket Woman

COLLAGE ON BOARD

14 x 18 inches | 1971

With shotgun field houses in the background, a woman walks away from a cotton field carrying a basket on her head. Her large hand gently guides a little girl walking in front of her while she continues to balance the basket with her other hand. In this work, Bearden replaces his painted images of fieldworkers and sharecroppers as represented in earlier works with composite images drawn from magazines and other photographic sources. The need, to show the strength in hands, and the postures of those engrossed in work, remains a current in Bearden's interpretation of black life. The cotton field becomes a universe, a mass of white on dark so dense, so vast, that one knows that the workers dreamt of the cotton at night, the white spot burnt on their eyelids like snowblindness. The women in the fields have their heads cut by the horizon line. Only their heads rise above the surrounding cotton. While four figures work on at their endless task, four others either pause to confront the viewer or to reflect within themselves. The basket woman has a face that seems inspired by West African wood carvings. She brings food to the workers, providing them with sustenance and a pause to regroup their weary bodies. In the background, smoke rises like huge puffs of cotton against a bright yellow sky. Behind the scene loom the green forms of the North Carolina mountains, a terrain that Bearden would remember from his own childhood. The height of the woman is intensified by the dignity of her bearing as she walks away from the cotton fields, while Bearden captures with great tenderness the intense concentration of the young girl trying to manage by herself the bulk and the weight of her big bag. It is this seriousness of intent, often seen in young children engrossed in a task, that makes the work so real. The beauty of the white scattered across the picture plane and the almost playful quality of the single cloud in the sky create an ironic undertone of visual joyfulness in the midst of this scene of drudgery.

GRANT HILL: This scene calls to mind all that I have read and heard about life in the South after slavery. It makes me very aware of the endurance of our ancestors. My father's family, like Bearden's, has deep roots in North Carolina and there is a familiarity to these scenes that I gather from the stories of my father's visits to his family home.

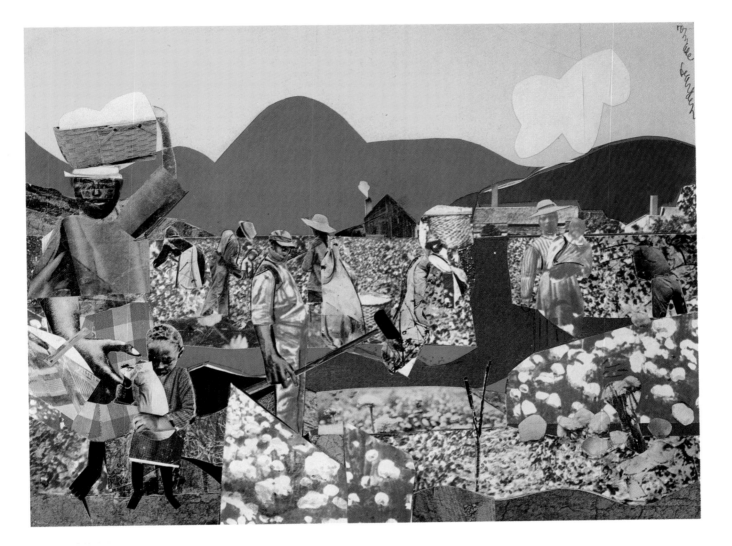

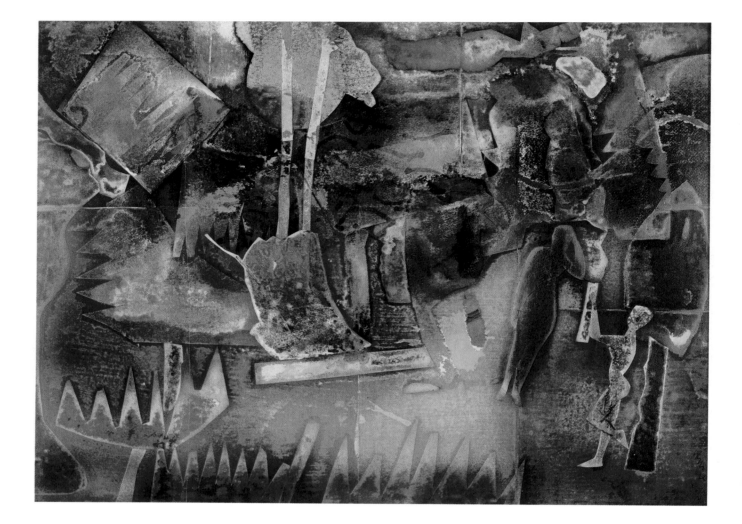

ROMARE BEARDEN

The Rain Forest, "An Old Dream"

GOUACHE AND COLLAGE

18 x 24 inches | 1973

This work is one of Bearden's most subtle in terms of its interpretation of color and the human form. Lost in washes and clouds of green color, one finds two figures, one beneath a tree, while in the middle ground what looks like a primordial water force moves with great waves into the foreground. The yellows and oranges fade in and out of the picture, much like sunlight filtering into a rainforest through its canopy of great trees. Bearden defines the richness of the color green and its association with the most fundamental measure of life in his fluid interpretation of color and light. The result is a work of a haunting and dreamlike quality, delicate and infinite in its passages of beauty.

GRANT HILL: The quality of a dream is very strong in this work to me. The fact that Bearden calls it an "Old Dream" says that it is a dream that he has had more than once. Perhaps this is why there are so many layers in the work. He is trying to show us how many different aspects of the "Old Dream" he can recall.

ROMARE BEARDEN

Time for the Bass

COLLAGE ON BOARD

9 x 6 inches | 1979

The power of this image comes from its simplicity. Here the bass player leans over his instrument in concentration, his own bulk pulling from the massive yet feminine form of the instrument a completely original and mellow melody. Behind the figure, Bearden has painted a roughly jotted abstracted script in bright colors. The artist's free-form visual hieroglyphs match the originality of the bass player's solo. Within the African American community, and among lovers of jazz, there is a special appreciation for the talent of the bass player, for his is an instrument difficult to unlock in terms of its possibilities of subtle variation. Those who have "the touch" are able to reach these heights of creativity and become acknowledged masters of this monumental musical instrument.

GRANT HILL: I know that Bearden was a jazz lover and a friend to many musicians in Harlem. This work reminds me of that love of jazz music that Bearden had all of his life. The musician, dressed in his dark suit and bright tie, reminds me of musicians that would have played during the era when black musicians were "clean," as they used to say. This man looks as if he would play for the MJQ, the Modern Jazz Quartet, a group that was in its heyday back in the 1960s and 1970s.

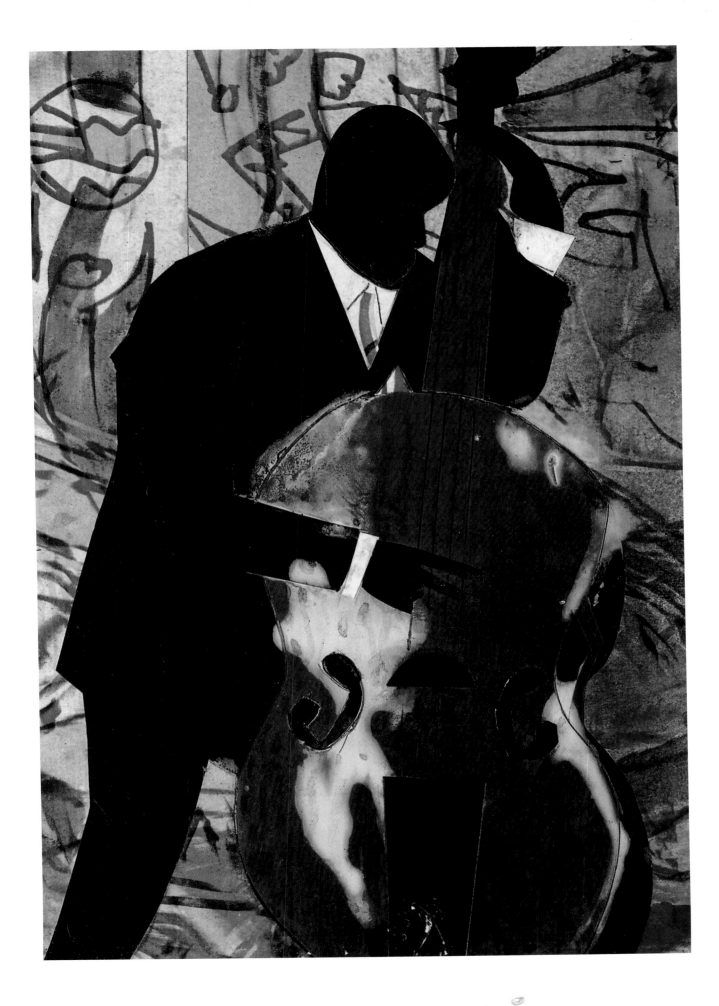

ROMARE BEARDEN

ROMARE BEARDEN
Mother and Child
WATERCOLOR
30 x 22 inches | ca. 1980s

The lush fluidity of this image underscores the link between the mother and her child. Bearden appears to connect the two with broad brush strokes and continuous line, defining them in a rich indigo blue, while leaving major areas white. The abstract quality of the work again indicates the timeless quality of the representation. There is a spiritual basis to the work rather than a didactic interpretation. Unlike in many of Bearden's collages, which rely upon hard-edged definition, the appearance of the painting is one of fusion and symbolic connection.

GRANT HILL: This is a very beautiful rendering of the close relationship between a mother and child. It is very interesting to see how Bearden can work in a number of different media and I think that the watercolor in this piece works especially well.

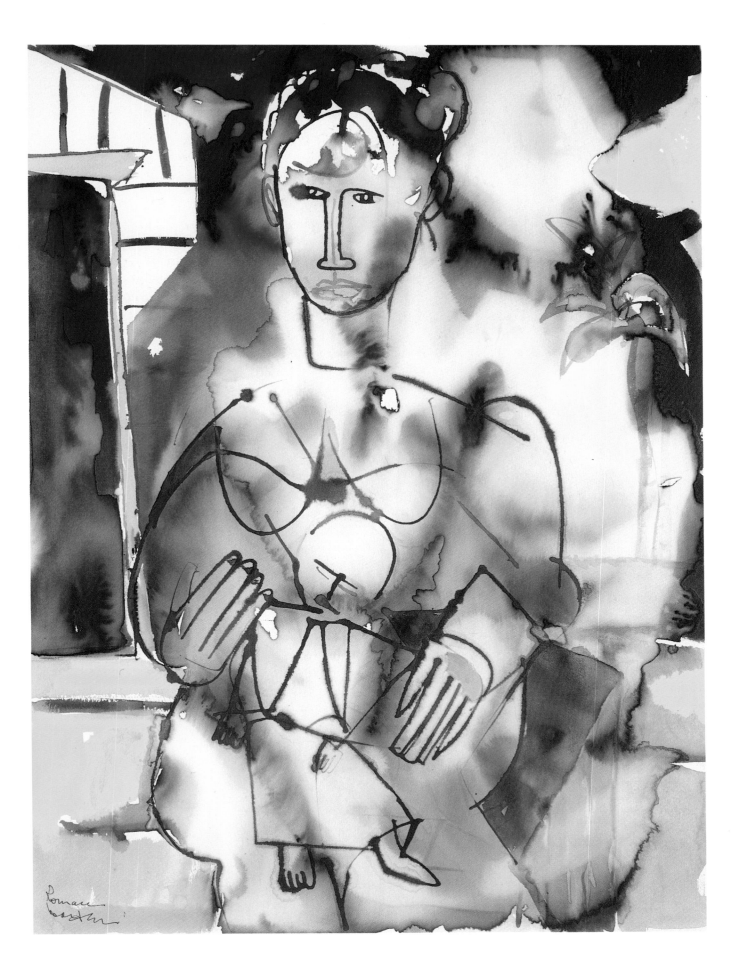

ROMARE BEARDEN

Morning Charlotte

COLLAGE ON MASONITE

16⅞ x 19 inches | 1985

Cooking, preparing for morning, light coming through onto the table draw the viewer into this intimate setting. This soft bustle of a morning characterizes the work in which three women in a front room prepare food and set the table for breakfast while in the rear bedroom a woman prepares to dress. Morning sunlight bathes the figure seated at the table, probably a family elder, while a woman clad in an apron carefully and slowly carries to the table a bowl of something hot. Her stance indicates that she is focusing on not spilling the contents of her bowl. The combination of waiting, watching, and working in the front room juxtaposed with a totally separate act in the second room creates an intimate and realistic interaction among the occupants of the home. It was not uncommon for several generations of a family to live under one small shotgun roof in southern black communities, and Bearden's family experiences in North Carolina made him deeply aware of such intricacies of a Charlotte morn-

ing. The work is boldly constructed, with zones of color defining different individuals. The floral pattern on the floor accentuates the movements of the cook and connects her to the figure standing against the wall and the figure seated at the table.

GRANT HILL: I like the involvement of the women in this work. It reminds me of Phoebe Beasley's work *Test Pattern*, where one senses the camaraderie between the women at work on a sewing project. I especially enjoy this work because of the way that Bearden uses his bright colors as accents within the room.

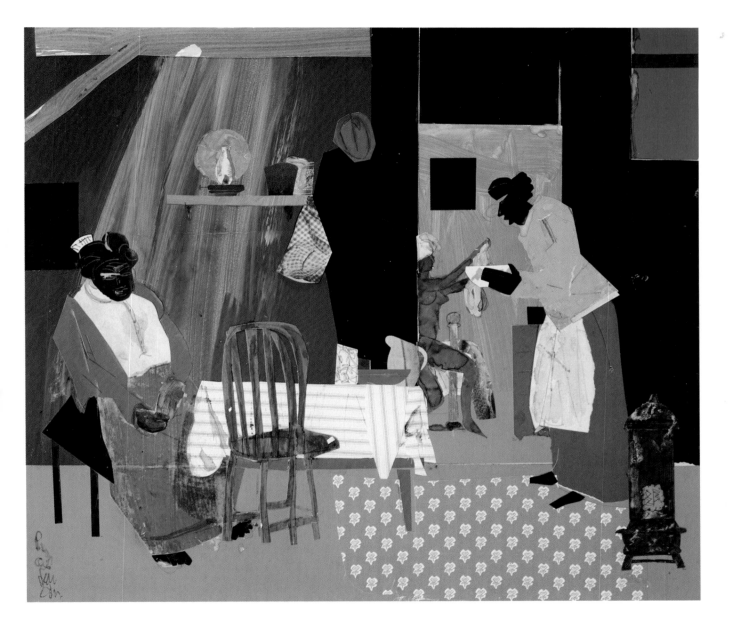

As a woman cooks, hunched over a mixing bowl, a young woman is at her toilette. The gingham of the title finds itself echoed in the older woman's skirt and at the window of the small house. The scene indicates how everyone in such tiny interiors could move about independently of one another, maintaining autonomy while in the same space.

GRANT HILL: The title of this work says everything to me. You can see how all of the activities of the early morning are captured by Bearden while the gingham of the tablecloth gives the home a very familiar quality. It feels like a home from the way it looks.

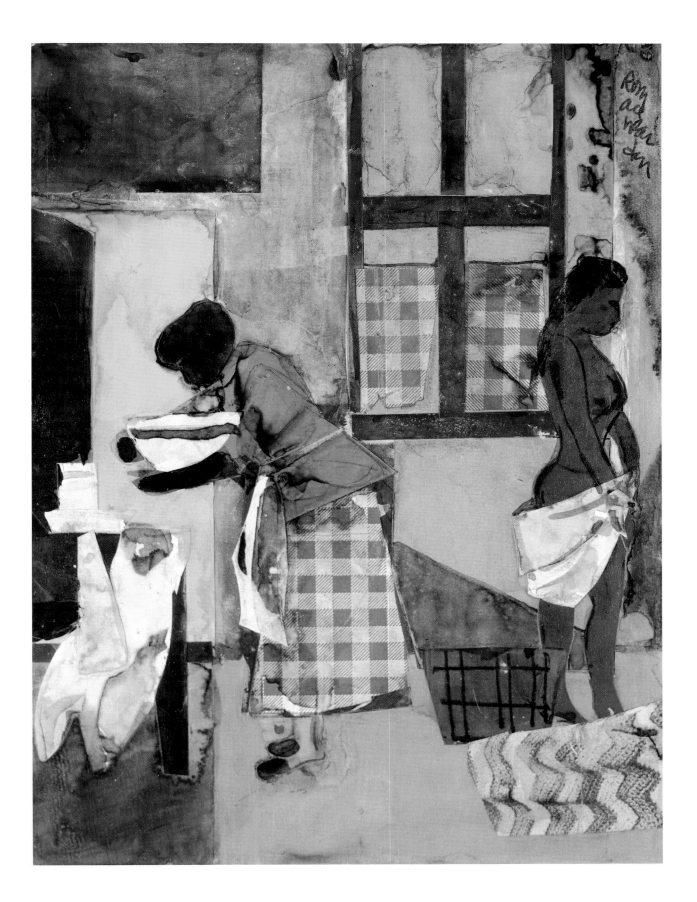

ROMARE BEARDEN
The Street

WATERCOLOR AND COLLAGE ON BOARD
20 x 28 inches | 1985

The strong dynamics of the urban street scene create a fundamental characteristic of the art of Romare Bearden. In this work, the elements of street life—the movement, sound, personal interaction—are all shown with sharp precision and a knowing recognition. The distortion of figures and exaggerated forms evoke the unexpected bursts of energy that characterize the contemporary urban street. Bearden's overlay of images in the collage and the strong juxtaposition of color give the viewer the impression of being a part of the scene, a part of the crowd, interacting directly with the activity that dominates the work. Because Bearden lived in New York for decades, the dynamics of the scene are second nature to him, just as a jazz riff is to a masterful soloist. He brings to bear much of the repartee and genius of street exchange that often result in new art forms such as jazz and hip-hop in major African American communities.

GRANT HILL: This work captures for me the energy that anyone can see and absorb in any urban black community, be it New Orleans, Baltimore, or Detroit. The sounds and sights of the African American community are unique. I like the way that Bearden overlays music and movement and conversation, just as one sees on the street.

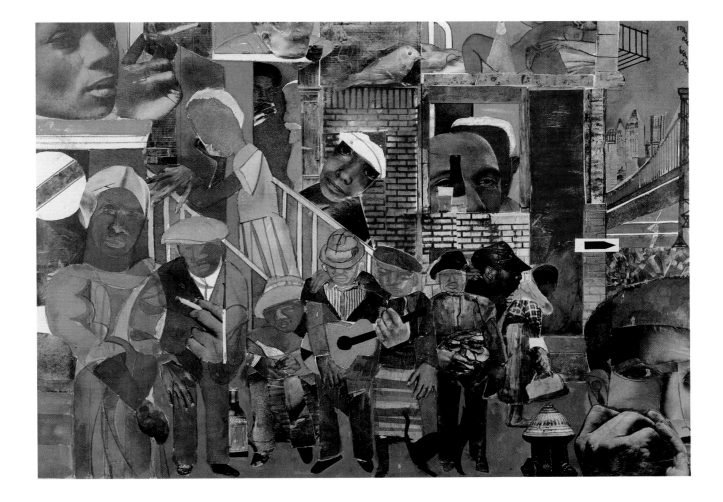

ROMARE BEARDEN

The Evening Guitar

WATERCOLOR AND COLLAGE ON BOARD

20 x 24 inches | 1987

Bearden creates a modest interior in which activities marking the end of the day are carefully recorded. Much like Vuillard or Bonnard, whose domestic scenes depicted the intimate interiors of nineteenth-century French life, Bearden captures in his collage the stillness and quiet of small activities repeated daily. Not regarded as important in the grand scheme of life, these movements and activities, such as reaching for the guitar at the end of the day for a moment of relaxation, create personal definition to one's life. For Bearden, such small scenes become major themes. Seated on her bed, a woman rubs her feet as she changes out of her work clothes, her sunhat nearby on the floor. She is now in a mood to relax, having cleaned house and worked all day. A teapot is on the stove, as if waiting for her to make a pot of coffee or tea for herself. The indigo walls, the mirror and open window, all suggest a quietude that will be broken only by the pleasant chords of a nearby guitar hanging on the wall. Bearden's emphasis on the importance of music in the black world is suggested by the frequency with which he includes the act of playing music or the presence of an instrument in his work. One can imagine the melodies that would be played on that guitar, joined by voices and often the tapping of feet.

GRANT HILL: I think that we can all relate to the day's end state of being, be it weary with aching feet that Bearden shows us or weary from the many stresses of contemporary life. Bearden brings home the meaning of survival and renewal because the title suggests that the evening will also have the guitar to make it even more restful and renewing.

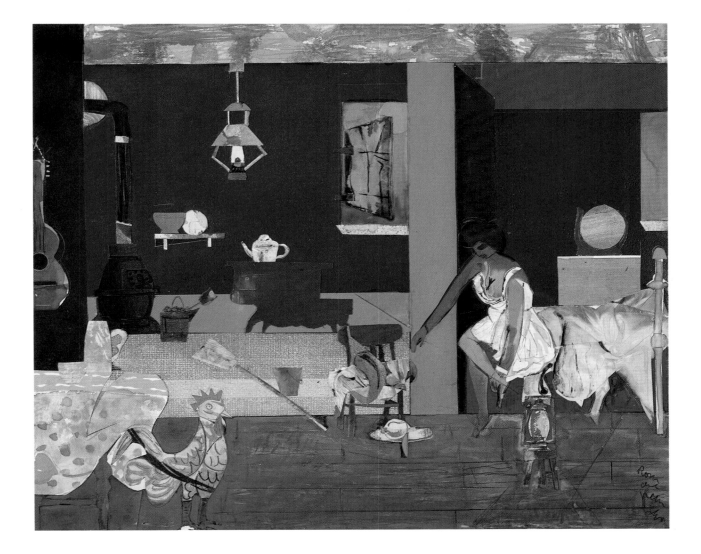

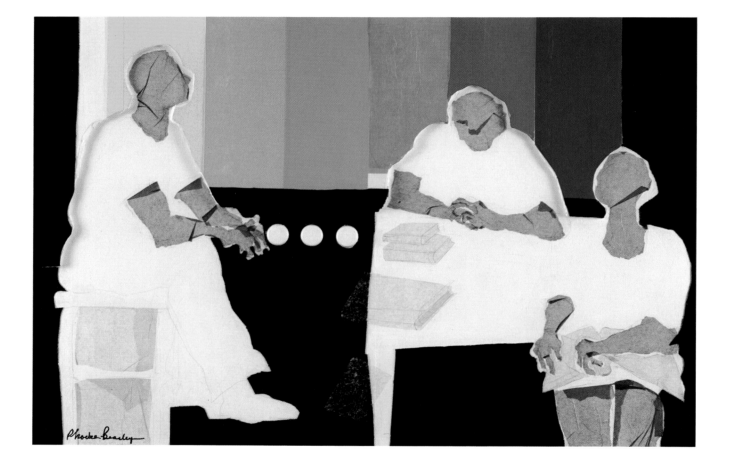

PHOEBE BEASLEY
Test Pattern
COLLAGE
26 x 37½ inches | 1994

The broadly constructed images in this collage represent a double entendre on the title. The bright band of colors behind the three people working creates a test pattern of the sort that one sees on the television screen. The figures themselves seem to be cutting out clothing "test patterns," to make a new garment. There also appear to be books on the table; these objects could refer to another kind of intellectual test that the individuals must face. The work is simply conceived, with an economy of means that heightens its graphic quality.

GRANT HILL: I like the way Ms. Beasley uses very simple colors and a great deal of black and white to construct this work. I think it has a very contemporary feel to it.

ARTHELLO BECK JR.

Confrontation

OIL

31 x 36¾ inches | 1969

Captured in this painting is the dramatic change, conflict, and rebirth that defined the 1960s. This work was collected quite early in his career by Calvin Hill and remains a favorite work of the family. Arthello Beck captures the energy and urgency of the times as he depicts figures forcefully wrenching their bodies and wrestling with one another, when in actuality they are wrestling with issues larger than themselves. Beck is masterful in his emphatic rendering of the human form, and the focus upon the figures alone without a surrounding context makes Beck's work even more dramatic in its impact.

GRANT HILL: I grew up with this painting, and just as my father is attached to it because it reflects the historic struggle of the black male, so am I.

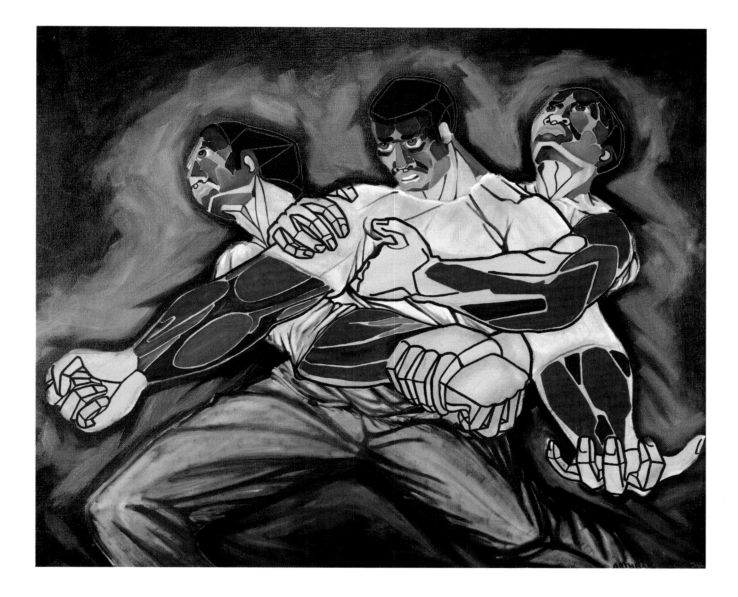

JOHN BIGGERS

The Upper Room

COLOR LITHOGRAPH

36 x 22 inches | 1984

Developed from a detail of John Biggers's mural *Family Unity*, this lithograph reflects the artist's lifelong celebration of black women and their central role in maintaining continuity within the African American family and community. Known for his depictions of African American traditional life in the South, Biggers creates in this work a complex of symbols that refer to the image of the "Upper Room," described often by Biggers as that spiritual space that one is able to reach even in everyday life with the proper guidance and orientation. The women holding up the house parallel the figures in Elizabeth Catlett's sculpture in their expressions of strength and caring. The figures walk into the future, bearing their responsibilities of providing order and continuity within the home, church, and school. The structure contains in its interior a table and a bed, suggesting the domestic responsibilities of the women. The women are preceded by a row of animals suggesting the strong connection of families to the land around them. On the right side of the work is a rendering of a bottle tree, an icon of southern culture found frequently in the yards of rural homes and a symbol of protection for the household. Biggers's liberal use of deep indigo in this lithograph suggests at once the traditional indigo tie-dye brought to the coastal Carolinas by West African women and the deep color of a southern night sky.

GRANT HILL: The Upper Room contains so many of the elements that one sees in the art of Bearden, Catlett, and Hughie Lee Smith. The determination of the female, the culture of the South, and the connection with the surrounding nature are all in this work. You can almost feel the movement of the women as they move forward, carrying the household and culture with them.

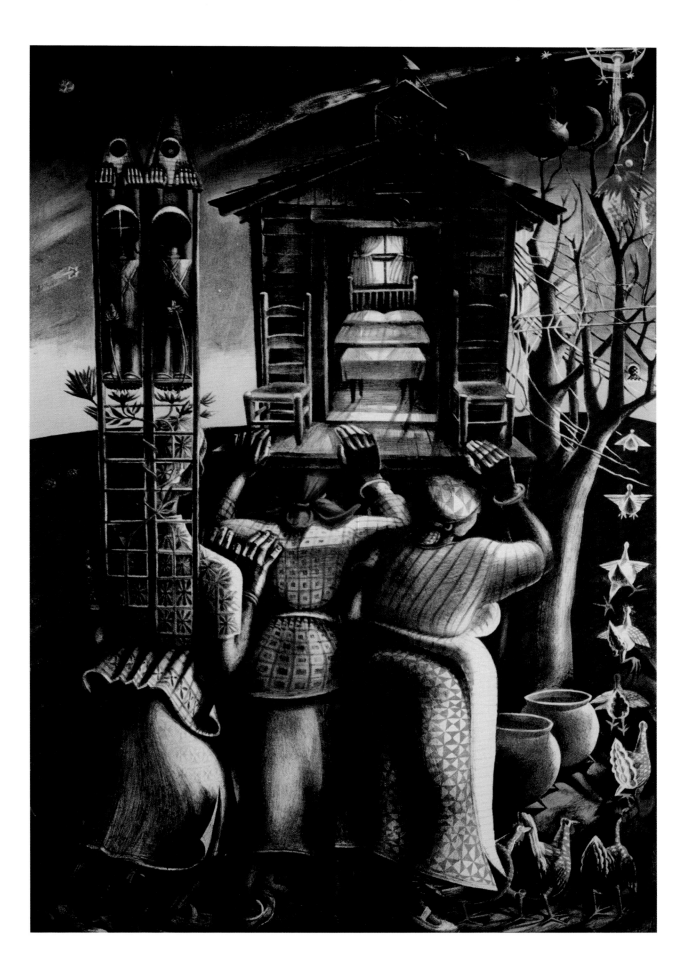

MALCOLM BROWN

Innocence

WATERCOLOR

30 x 37½ inches | 1991

A young girl gazes upward, standing against what appears to be a wide-planked old building. Her simple shirt suggests that she is from a family of limited means. Her facial expression is one of openness and questioning. The girl is reminiscent of the images of many children that one saw during the Depression, innocent youth that seemed caught in the middle of a human storm that they did not create, yet reality dictated that they had to follow wherever the winds of change took the adults around them. The watercolor medium underscores the fleeting quality of the girl's expression as well as the timelessness of the overall image. The work calls to mind the future of all children. Malcolm Brown has a gift for creating portraits of all ages.

GRANT HILL: This artist has captured in the girl's eyes both vulnerability and challenge. I especially like watercolors that can convey human personality in portraits such as this one by Malcolm Brown.

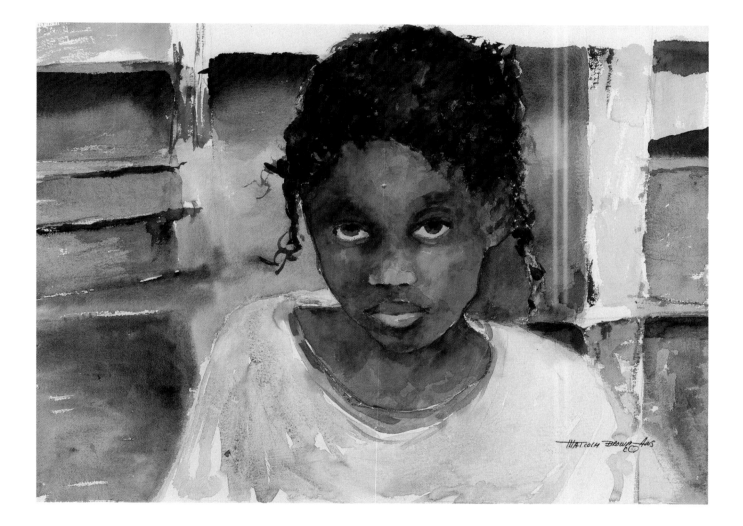

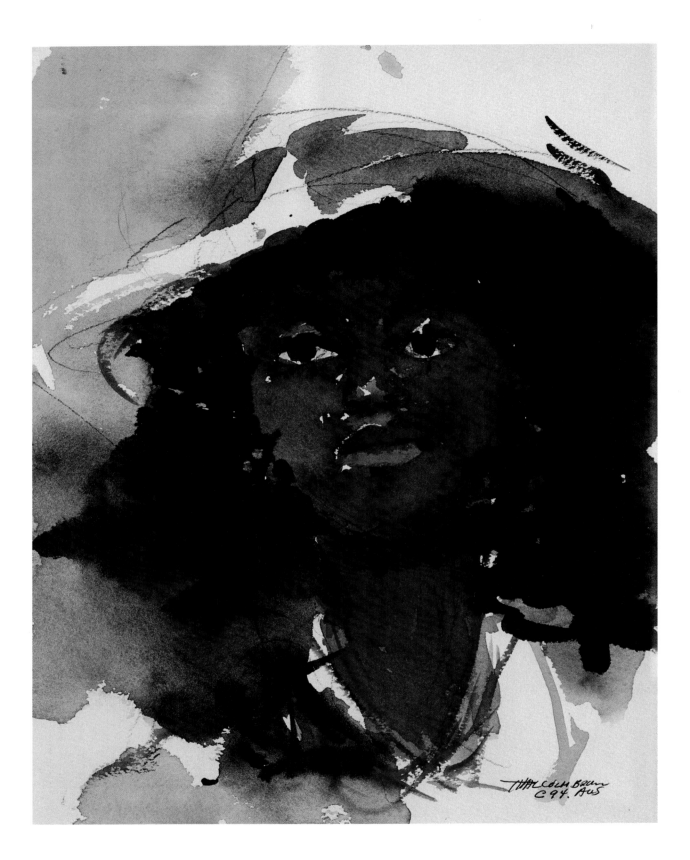

MALCOLM BROWN
Sophisticated Lady
WATERCOLOR
18¼ x 15¼ inches | 1994

A lady in a broad-brimmed sunhat in white sets forth a beautiful image of black femininity. Among black women, the wearing of a hat is a sign of sophistication and being completely "dressed." There is a sweetness of gaze that comes forth from beneath the hat and is accentuated by the youthfulness of the woman's face. The artist uses the white of the paper to give the face a freshness and to match the white of the hat and the dress. He achieves great subtlety with the watercolor medium by creating masses of hair about the subject's head as well as a suggestion of light behind her right side.

GRANT HILL: It amazes me that Malcolm Brown could capture the complex emotion in the face of this young woman using only watercolor. Although she appears, as the title suggests, as a "sophisticated lady," there is an element of sadness expressed somehow in her face, especially her eyes.

As a classic sculptor, Elizabeth Catlett
has always been interested in captur-
ing the human spirit as expressed in
timeless poses. Like many of her por-
trait busts, *Singing Head* reflects the
artist's ability to visually develop real
inner character while creating an ide-
alized image. The work has the direct-
ness and power of a West African Dan
mask in its features while expressing
the fleeting beauty of a creative, hu-
man act—the moment of song. The
works of Catlett have very immedi-
ate links with African, African Ameri-
can, and Latino cultures. Throughout
her career, the artist has made it a
major goal to represent the women
of these cultures as icons.

GRANT HILL: It is amazing to see
how Ms. Catlett can make the bronze
form come to life in a movement of
song. I love music, and because my
wife is a singer, this piece has special
meaning to me.

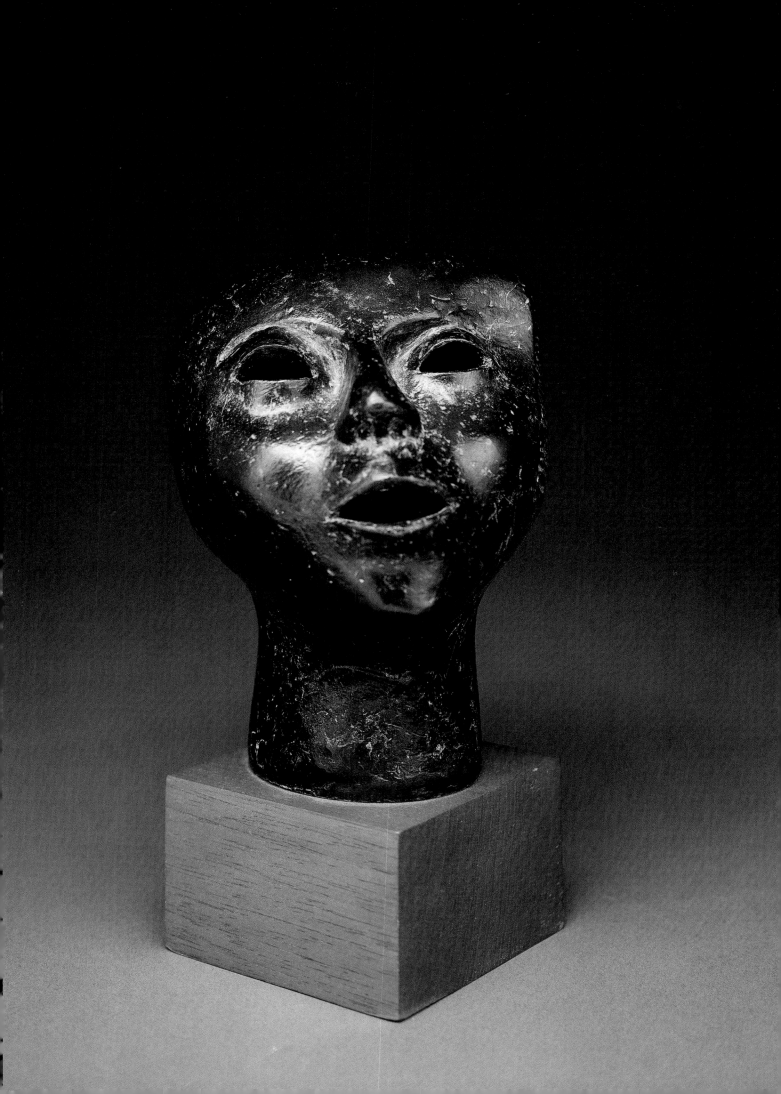

ELIZABETH CATLETT

Standing Mother and Child

BRONZE | 1978

© Elizabeth Catlett / Licensed by VAGA, New York, N.Y.

The act of standing and holding a child gives the mother a posture of strength. The mother retains a close connection with the child. The endless variations of the relationship of mother and child are expressed in a number of Catlett's maternity figures, and in many images of mothers with their children in cultures throughout the ages and throughout the world. The weathered patina on this version of the standing mother yields an even greater feeling of endurance.

GRANT HILL: This work represents for me the strength of black womanhood. Now that I am a father, I can truly appreciate the bond between parent and child. As a protector and a source of strength for the child, a parent, especially the mother, must always be there to both love and counsel. There is so much movement upwards in this work that indicates this kind of strength in the mother.

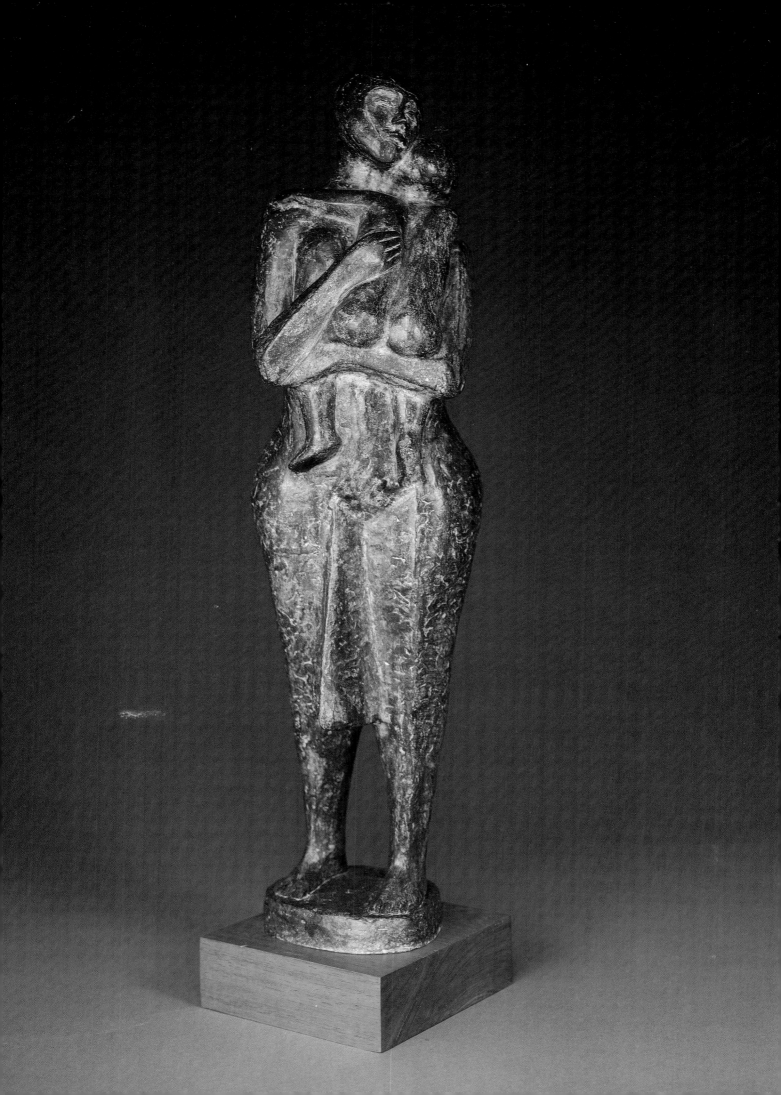

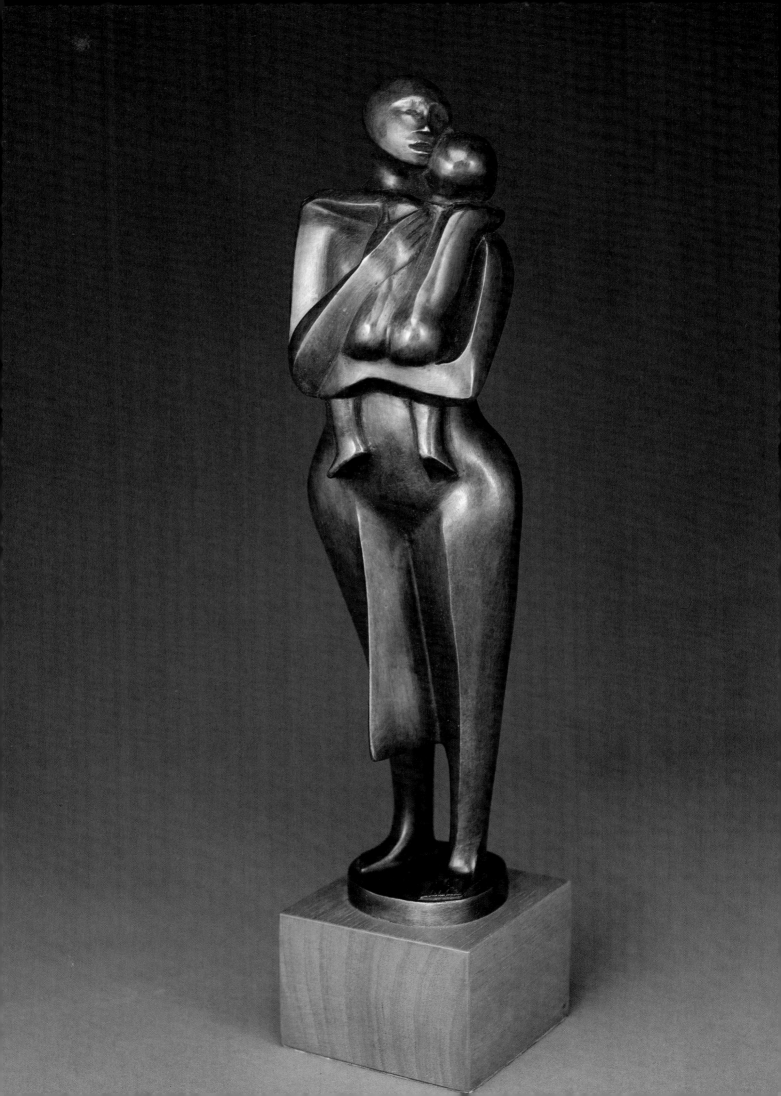

ELIZABETH CATLETT
Standing Mother and Child
BRONZE | 1978
© Elizabeth Catlett / Licensed
by VAGA, New York, N.Y.

Cast from the same form as the pre-
vious work, this mother-and-child
sculpture has a warm, deeply hued
bronze patina that underscores the
loving connection between the two
figures. The two sculptures demon-
strate how the mood of a work can
be altered by changing its surface
tone and texture. The bond between
mother and child is suggested by the
visual closeness of their two heads,
while the strength of the mother is
suggested by her broad hips and the
angularity of her limbs; the lower
portion of the woman's body is a
foundation upon which the bonding
interaction between mother and child
comfortably rests.

GRANT HILL: This posture of the
strong mother is the kind of work that
speaks to everyone in a universal vi-
sual language. The image of the
mother and child in art goes all the
way back to Egypt and certainly the
Madonna and child representations
of the Renaissance are still important
works today. Catlett's mother and
child figures contribute to this tradi-
tion.

ELIZABETH CATLETT
Glory
BRONZE | 1981
© Elizabeth Catlett / Licensed
by VAGA, New York, N.Y.

This bronze portrait bust has large, seeking eyes that seem to be illuminated within the face. Complementing the huge eyes is a secure mouth with a gentle smile. The portrait bust is a form in which Catlett excels. In focusing upon the head, the artist is giving a signal that the person, the personality, the essence of thought of the person is what matters. As a sculptor, Catlett is renowned for her ability to translate, with a deliberate economy of means, the nobility and monumentality of her subject.

GRANT HILL: The beauty of this work is in the strength of the gaze of the woman. Her steady gaze seems to penetrate into space, and actually connect with your own vision.

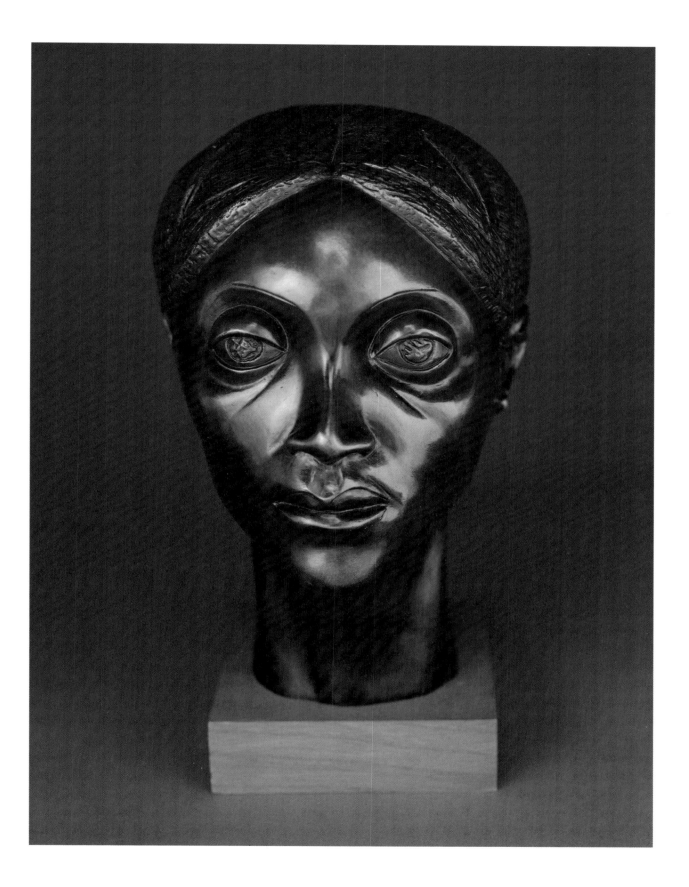

ELIZABETH CATLETT
Cartas

LITHOGRAPH
28 x 19 inches | 1986
© Elizabeth Catlett / Licensed
by VAGA, New York, N.Y.

Drawn to Mexico by its ancient print-making tradition, Catlett remained there and worked with artists like her husband, the master printmaker and painter Francisco Mora. Catlett has continued to create images of African American women in her extended efforts at developing a series of images reflecting the true women of the world, especially women of color. This poignant work was created as a tribute to the film *The Color Purple*. The title refers to those letters, cartas, that the heroine never received from her sister.

GRANT HILL: I love the way that Elizabeth Catlett captured everything in the face of the woman: the animation, the reflection, the thoughtfulness. It is a very compelling portrait.

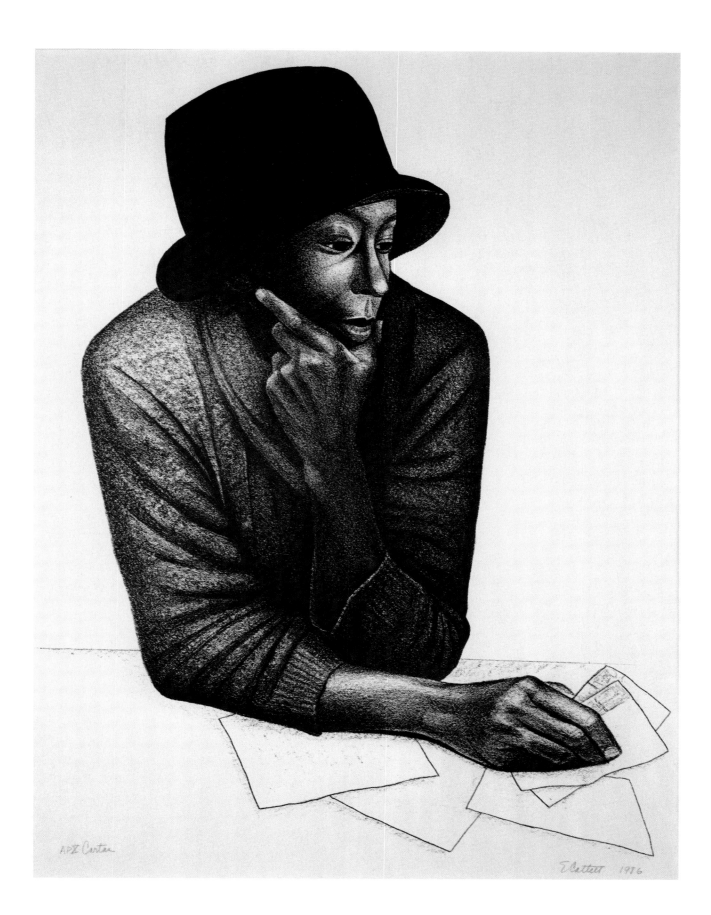

E Catlett 1986

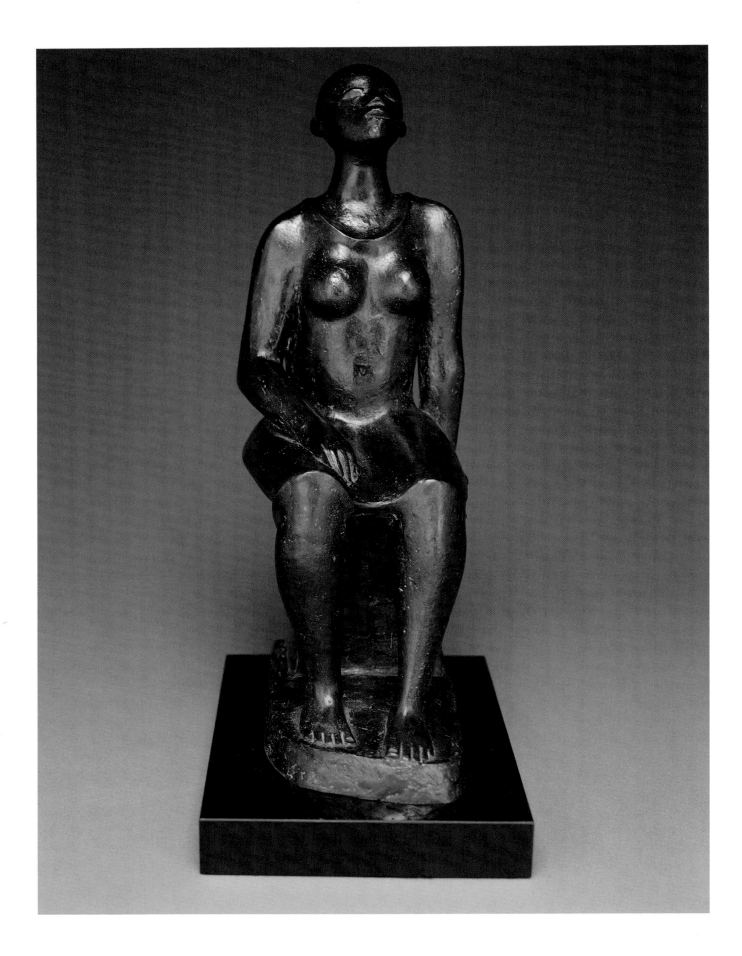

ELIZABETH CATLETT
Seated Woman
BRONZE | 1987
© Elizabeth Catlett / Licensed
by VAGA, New York, N.Y.

The nobility and strength of this figure are underscored by a posture of thoughtfulness and awareness. Her attenuated neck and long arms again suggest dignity and enduring strength. The figure calls to mind the heritage that the artist has experienced in both the African American and Latina cultures. Seated female figures such as these are commonly depicted in African cultures as well. An example is the seated female form of ancestral figures, such as the female figure seated on the Akan stool throne of Ghana. Catlett deliberately strips down each of her figures to the bare essence of her being to show who she is as a human presence. There is no detail of clothing, indeed no specificity of physical appearance, as the woman's character shines through.

GRANT HILL: Even sitting, this figure conveys great strength. Like the artist herself, the figure expresses great inner power. This is what I love about Catlett's sculptures: they command your attention while being simply strong and beautiful.

ELIZABETH CATLETT

Dancing

LITHOGRAPH

28¾ x 33½ inches | 1990

Commissioned by the
Stevie Wonder Foundation

© Elizabeth Catlett / Licensed

by VAGA, New York, N.Y.

As a printmaker, Elizabeth Catlett has the ability to create a variety of styles in her compositions. In this work, she chooses a very fluid style that echoes the fluidity of the dance itself. The lightness of the figures, their interaction with one another, are both captured in Catlett's composition.

GRANT HILL: This is a beautiful expression of the beauty of dance. It could represent any culture at any time and I think Ms. Catlett has expressed the moving quality that music has upon the human soul.

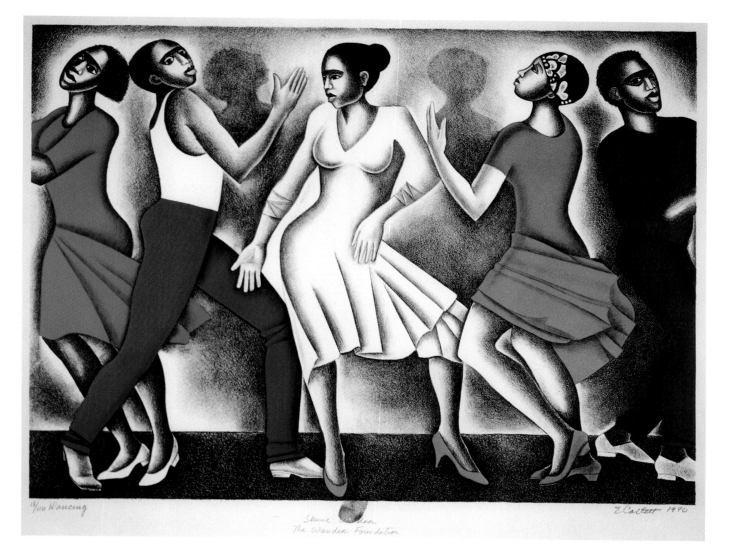

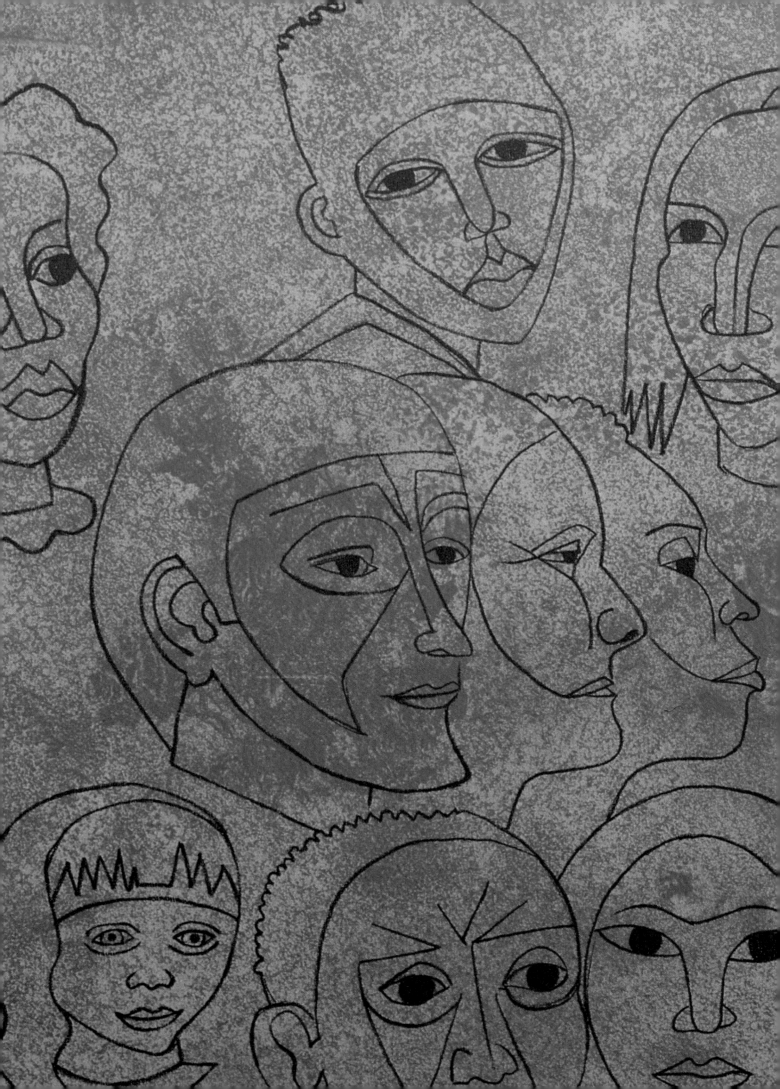

FOR MY PEOPLE

Margaret Walker

For my people everywhere singing their slave songs repeatedly: their dirges and their ditties and their blues and jubilees, praying their prayers nightly to an unknown god, bending their knees humbly to an unseen power;

For my people lending their strength to the years, to the gone years and the now years and the maybe years, washing ironing cooking scrubbing sewing mending hoeing plowing digging planting pruning patching dragging along never gaining never reaping never knowing and never understanding;

For my playmates in the clay and dust and sand of Alabama backyards playing baptizing and preaching and doctor and jail and soldier and school and mama and cooking and playhouse and concert and store and hair and Miss Choomby and company;

For the cramped bewildered years we went to school to learn to know the reasons why and the answers to and the people who and the places where and the days when, in memory of the bitter hours when we discovered we were black and poor and small and different and nobody cared and nobody wondered and nobody understood;

For the boys and girls who grew in spite of these things to be man and woman, to laugh and dance and sing and play and drink their wine and religion and success, to marry their playmates and bear children and then die of consumption and anemia and lynching;

For my people thronging 47th Street in Chicago and Lenox Avenue in New York and Rampart Street in New Orleans, lost disinherited dispossessed and happy people filling the cabarets and taverns and other people's pockets needing bread and shoes and milk and land and money and something—something all our own;

For my people walking blindly spreading joy, losing time being lazy, sleeping when hungry, shouting when burdened, drinking when hopeless, tied, and shackled and tangled among ourselves by the unseen creatures who tower over us omnisciently and laugh;

For my people blundering and groping and floundering in the dark of churches and schools and clubs and societies, associations and councils and committees and conventions, distressed and disturbed and deceived and devoured by money-hungry glory-craving leeches, preyed on by facile force of state and fad and novelty, by false prophet and holy believer;

For my people standing staring trying to fashion a better way from confusion, from hypocrisy and misunderstanding, trying to fashion a world that will hold all the people, all the faces, all the adams and eves and their countless generations;

Let a new earth rise. Let another world be born. Let a bloody peace be written in the sky. Let a second generation full of courage issue forth; let a people loving freedom come to growth. Let a beauty full of healing and a strength of final clenching be the pulsing in our spirits and our blood. Let the martial songs be written, let the dirges disappear. Let a race of men now rise and take control.

From Margaret Walker, *This Is My Century: New and Collected Poems* (Athens: University of Georgia Press, 1989). © 1989 by Margaret Walker Alexander. Opposite: detail from *All the People, from the series For My People*. Elizabeth Catlett, 1992.

ELIZABETH CATLETT
Singing Their Songs,
from the series For My People
COLOR LITHOGRAPH
26¼ x 23¼ inches | 1992
© Elizabeth Catlett / Licensed
by VAGA, New York, N.Y.

Inspired by the famous poem by Margaret Walker, "For My People," this work includes a woman on her knees in prayer, combined with profiles of heads that are singing or speaking and whose eyes are accentuated by their openness against the color of the background. The segmentation of the work into four grid forms is a technique that Catlett utililzes frequently in her later lithographs. This approach allows the artist to express several different themes at once, much in the way of a split-screen projection. The red, white, and blue colors of the grid create an ironic statement of historical context that underscores the strength of the images.

GRANT HILL: This reminds me of photographs that I've seen of young students singing during demonstrations in the civil rights movement. Music was such a part of the whole movement, and it serves as a source of inspiration for all human beings.

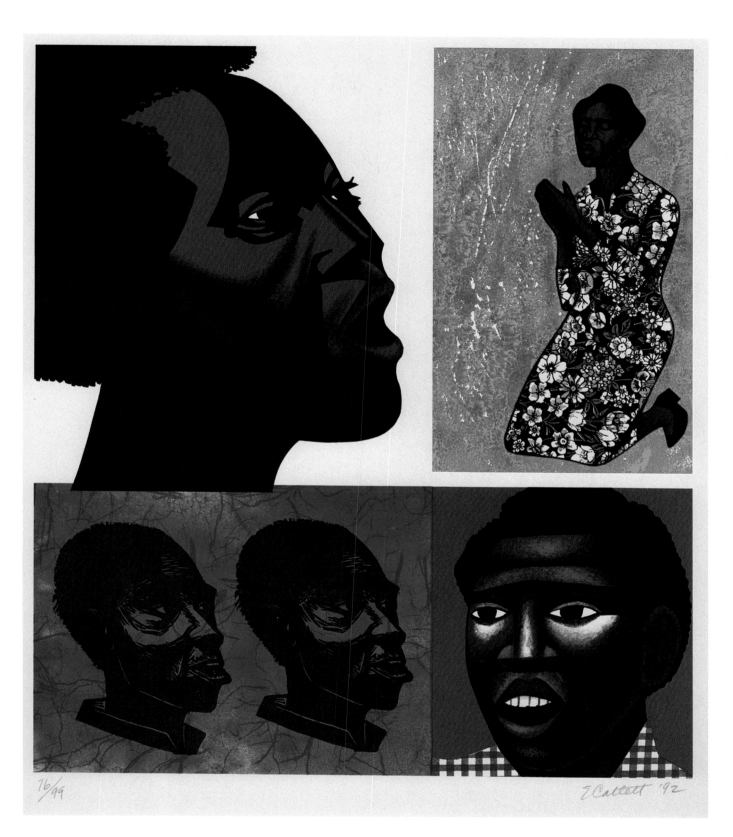

76/99 ECatlett '92

ELIZABETH CATLETT

Playmates, from the series
For My People

COLOR LITHOGRAPH

26¼ x 23¼ inches | 1992

© Elizabeth Catlett / Licensed
by VAGA, New York, N.Y.

In this work two children play with a red ball and wear bright clothing. The background, filled with earth tones, is highly textured, yet has no references to the rest of the world. The children hearken back to those days when life was innocent and fun, and playtime was the center of one's universe. The innocence of these two children at play suggests that they, like all children, have the right to their own childlike pursuit of happiness. In Margaret Walker's poem "For My People," a strong contrast is made between the children at play and the later burdens and barriers that face African Americans. Catlett's use of bright and primary colors underscores that this phase of life should be free of burden and focused upon the growth of the child's imagination and potential.

GRANT HILL: The beauty of youth, the innocence of those days, is shown in this picture. Catlett seems to love to use human beings as symbols of our own characteristics. The carefree nature of these children suggests a freedom and innocence that we have lost and are trying to reclaim. Perhaps in life, if people acted more like playmates as they encounter one another, there would be less acrimony among peoples of the world.

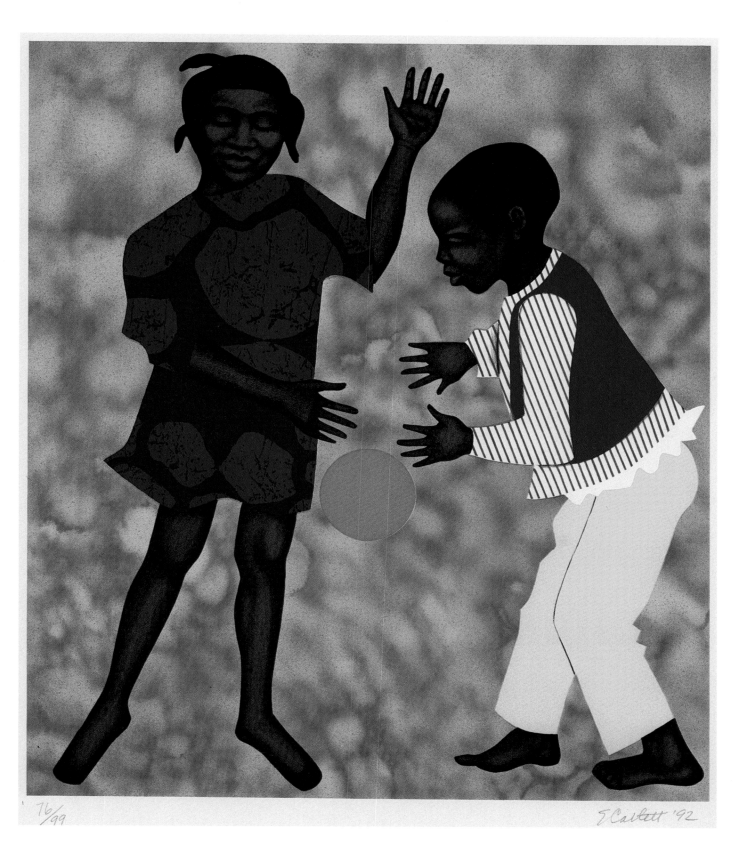

ELIZABETH CATLETT

To Marry, from the series
For My People

COLOR LITHOGRAPH

26¼ x 23¼ inches | 1992

© Elizabeth Catlett / Licensed
by VAGA, New York, N.Y.

A young newlywed couple, timeless and beautiful in their hopefulness, are juxtaposed with the figure of a young male on the ground against a fiery red background. What is the cause of this violence? The contrast of these images by Catlett is drastic. The red background of the bound man underscores the violence and brutality that he was subjected to. In this work, Catlett's mastery of the printmaking medium achieves maximum impact in her unrelenting and very direct interpretation of the extreme challenges and contradictions that surround African American families.

GRANT HILL: This is a very haunting image that reminds us of how the good and bad of life can easily collide. It also reminds me of the part of the marriage vow that says "for better or worse," for we do not know what is held in store for us or those we love in our lives.

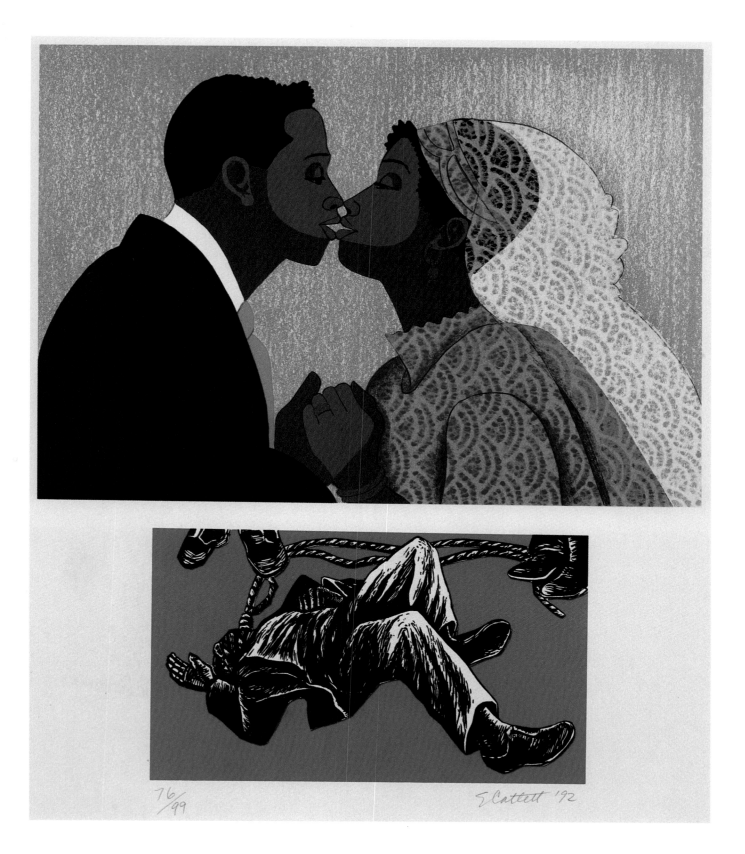

Walking Blindly, from the
series For My People

COLOR LITHOGRAPH

26¼ x 23¼ inches | 1992

© Elizabeth Catlett / Licensed
by VAGA, New York, N.Y.

A woman moves in the center of the
composition with arms upraised,
while against a gray background
move shadowy figures, fusing into
paper. A man holding a bottle or flask
looks downward, while another
woman raises both her arms as if
pleading with someone, while a
young boy sits on a stoop looking
downward. The subtle changes in
imagery in this work create a haunt-
ing quality that refers at once to
struggle, to despair, and to the diffi-
culties endured by ancestors as well
as those to be endured by a future
generation. A sense of moving out of
an abyss, of not knowing what to do
next, is a direct visual reference to the
phrase "walking blindly" in Marga-
ret Walker's poem.

GRANT HILL: The artist seems to
saying here that it is very difficult to
navigate through the morass of
difficulty that faces black people in
every phase of life. As we move
through the large and small crises of
life, our vision for our lives is tested
every day.

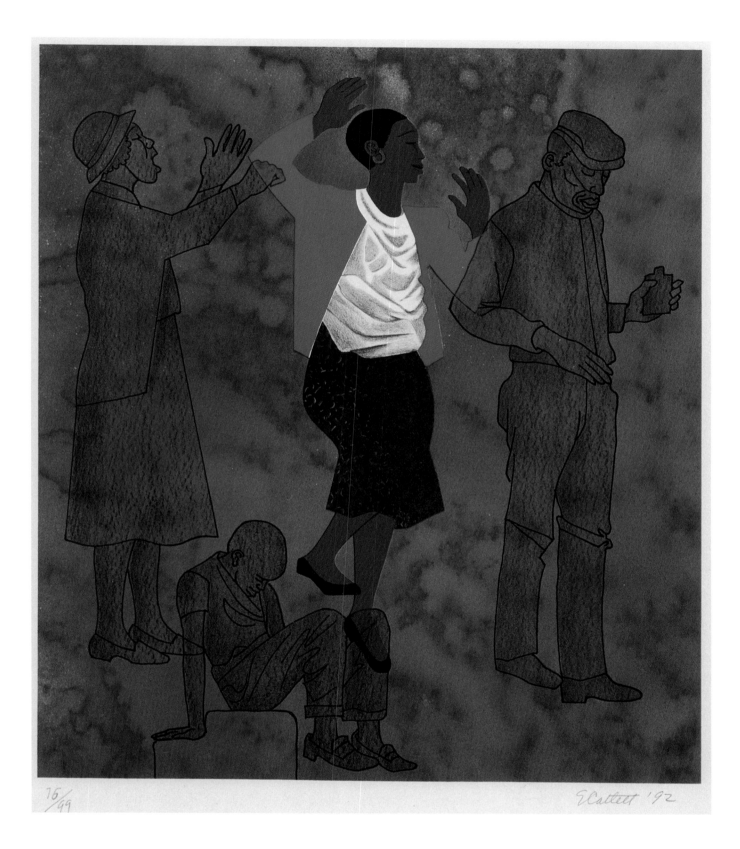

ECattett '92

The circular brown form that defines
this work contains the linear images
of men, women, and children look-
ing pensive while they are surroun-
ded with a turquoise, yellow, orange,
red, violet, blue, and green back-
ground. A graphic depiction of the
universality of communities of the
African diaspora, the work defines
the world in terms of generations
connected in struggle and in celebra-
tion.

GRANT HILL: It is interesting how
Catlett uses a very abstract motif to
suggest the concept of all the people.
The brown certainly connotes the to-
tality of black people. In an interest-
ing way it represents the earth itself
in all its age and texture.

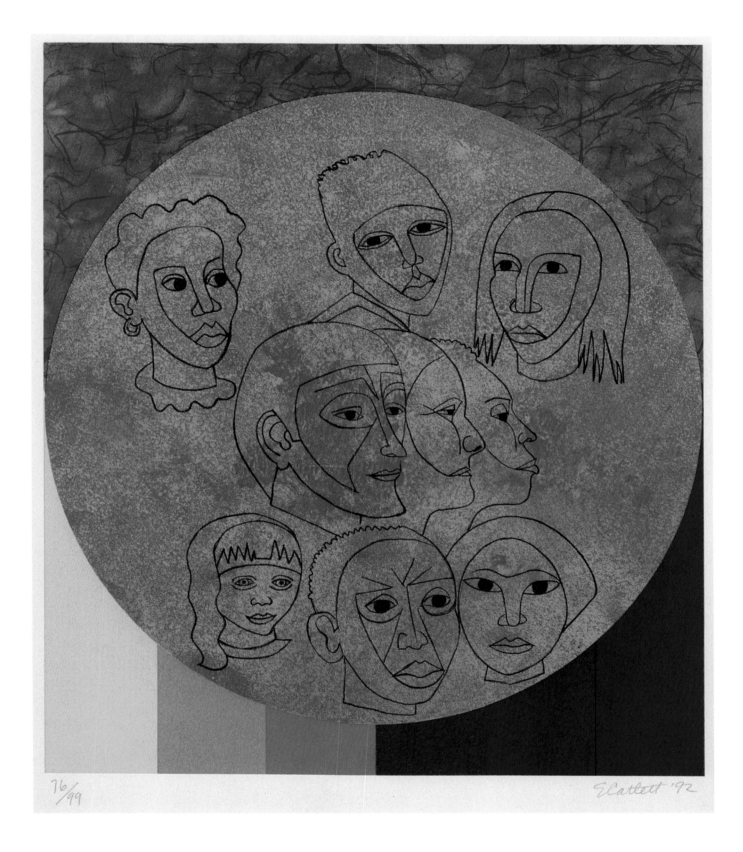

76/99 ECatlett '92

ELIZABETH CATLETT

A Second Generation, from
the series For My People

COLOR LITHOGRAPH

26¼ x 23¼ inches | 1992

© Elizabeth Catlett / Licensed
by VAGA, New York, N.Y.

The brilliance of the artist's color se-
lection with its fiery reds and oranges
serves to emphasize the strength of
the many movements that black
people have created and participated
in, from the silent marches down the
streets of Harlem to protest lynching,
to the March on Washington as an
iconic event in the civil rights move-
ment. Catlett captures with bold gra-
phic intensity the strength and deter-
mination of a new generation, as
reflected in the two heads silhouetted
against a strong yellow, red, and
white background.

GRANT HILL: These could be fi-
gures marching from Selma to Mont-
gomery, in the March on Washing-
ton, or in a more recent demonstra-
tion to protect our ecology or provide
proper care for children. What the
work conveys is a new generation
looking forward in determination
with a conviction to have its voices
heard.

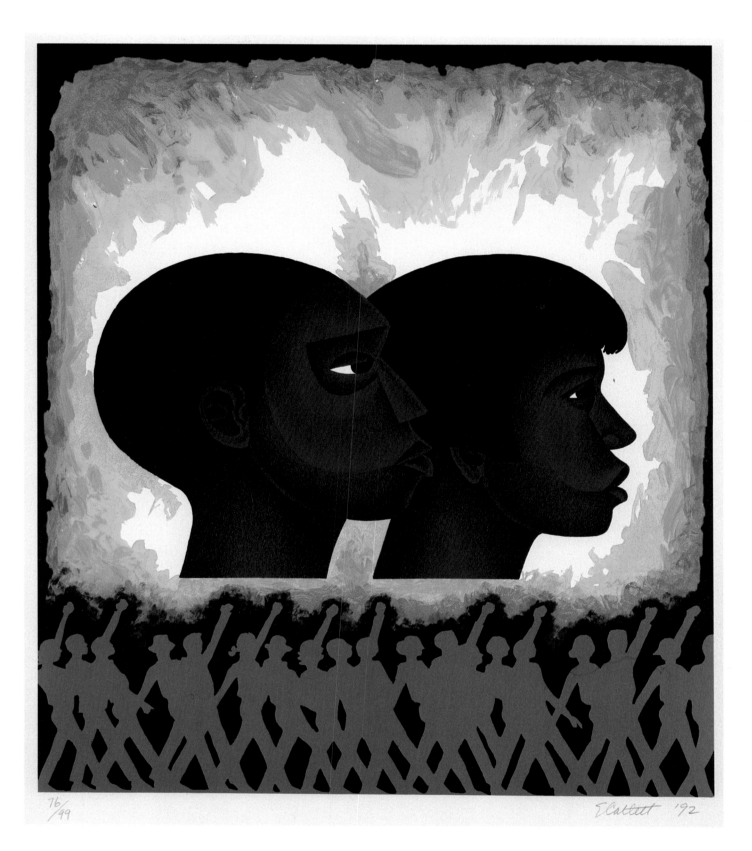

76/99

ECatlett '92

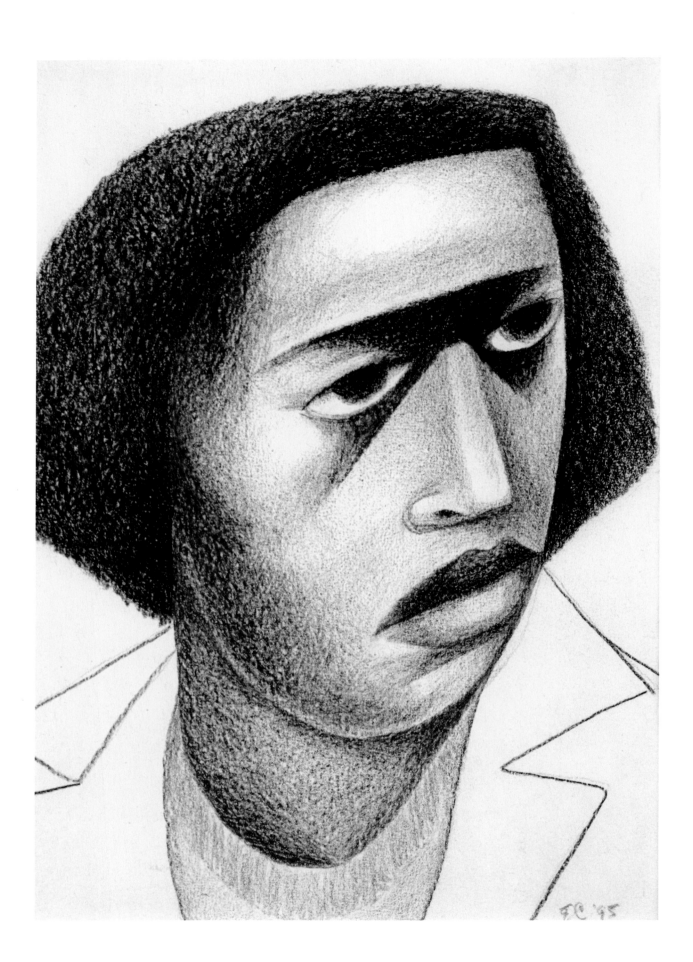

ELIZABETH CATLETT

Portrait

Intrigued by the images of black wo-
men, Catlett creates a number of por-
traits of thee women ranging from
very young to quite mature. In these
works, Catlett seeks to make the
women monumental in scale while
at the same time creating a very inti-
mate portrait. The artist is interested
in this work in capturing an image
that is not idealized but rather reflects
the strength of her character when
facing very real obstacles in life.

GRANT HILL: This is a very sensi-
tive image. Ms. Catlett clearly shows
the pain and concern in this woman's
face and you immediately are drawn
to her with concern. Because it is
such a simple portrait, the fact that
she has something weighing on her
mind becomes even more evident.

The figure is proud, thoughtful, and reminiscent of the famous Gordon Parks photograph of a domestic worker. The emphasis is upon her body, as she looks away, holding her tools. The genre nature of the subject, a woman laborer, is typical of Catlett's focus in her art. Catlett continues to represent the common man and woman in struggle and triumph. Her interest in printmaking was heightened by her work at the famous Taller de Grafico in Mexico.

GRANT HILL: I like the dignity of the woman shown in her height and the strength of her hands. She looks off into the distance as if there is something on her mind. She definitely is a woman of great strength and at the same time has great character in her face.

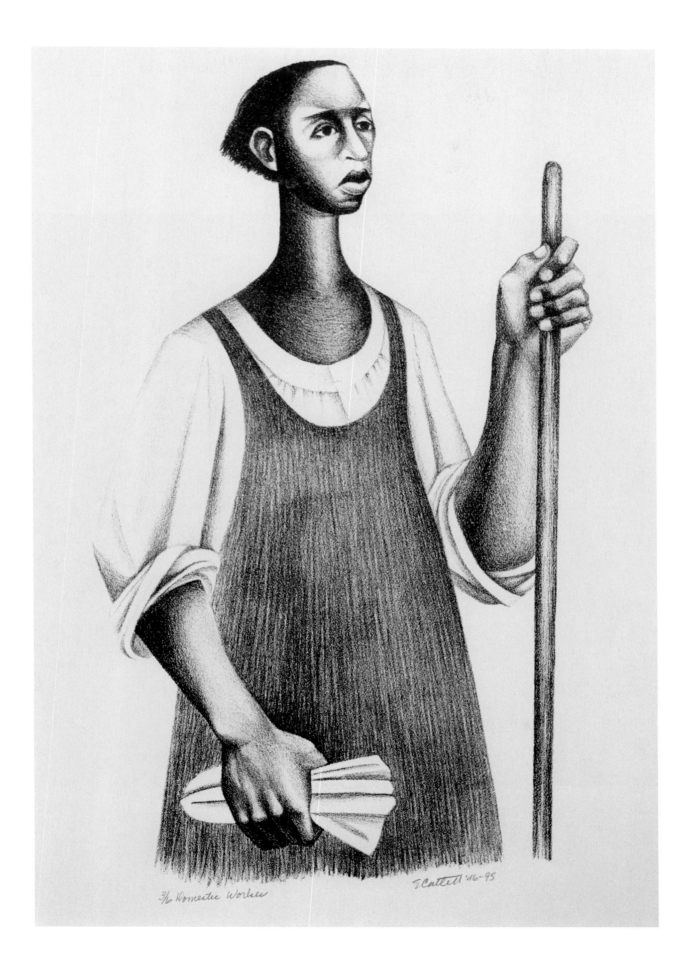

3/6 Domestic Worker ECatlett '46-95

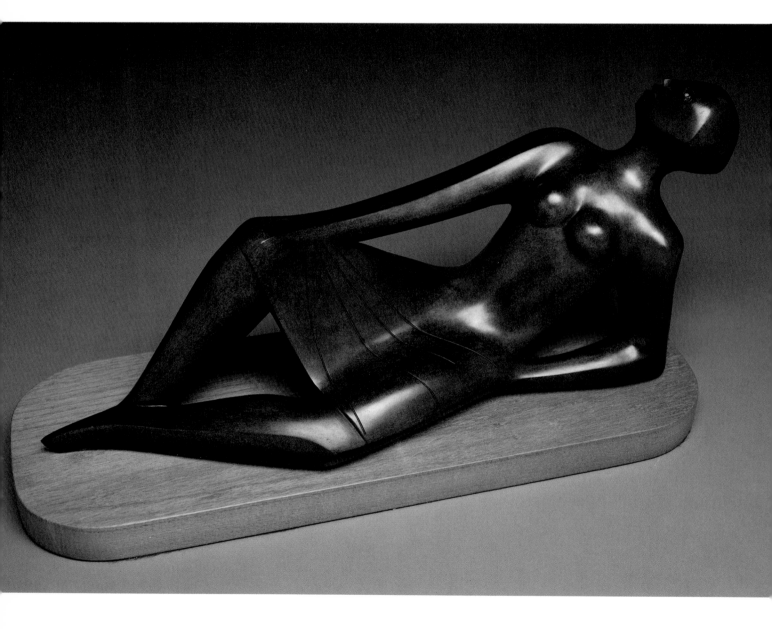

ELIZABETH CATLETT
Star Gazer

BRONZE | 1997
© Elizabeth Catlett / Licensed
by VAGA, New York, N.Y.

This figure has a relaxed posture. Leaning back, she looks upward at the stars. The blue marbleized patina underscores the nighttime setting of the work. Just as the physical act of looking up at the stars suggests something about the woman, so too does the material from which the form is constructed. The woman, obviously a figure of some strength, takes the time to look up at the stars and to examine the universe around her. Though perhaps burdened daily by the struggles and trials around her, she does not allow the beauty and mystery of the heavens to escape her gaze or her consciousness. The solitary nature of her looking up at the stars and the quietude and reverie which are suggested by the title indicate a freedom of spirit that is in direct contrast to the daily challenges that she faces. It is this contrast that makes the work all the more poignant in its beauty. There is an innocence, a renewal of spirit in this figure of a mature woman gazing at the stars. The title itself suggests patient, slow examination, a deep and yet relaxed concentration upon those aspects of nature that are beyond our reach and mental grasp, yet continue to call out to us with their constant presence. The nighttime setting recalls Bearden's *Evening Guitar*, which similarly depicts a respite from the everyday pace and drudgery of life, and like Hughie Lee Smith's *Dreamer* it represents an ascension of the spirit to a unique level, a level that is only for the soul of that one human being.

GRANT HILL: The relaxed pose of this figure is very beautiful. The way that she is looking upward connects the figure with the universe around her. It is a work to show that we all have dreams and times of reflection.

This work has a beautiful patina, and the flares on either side of the face accentuate the features. The fluting occurs visually as an expression of hairstyle, lending a strong three-dimensional interest to the work.

GRANT HILL: It is interesting how the relationship between Elizabeth Catlett's drawings and her sculpture is so evident. The same form and volumes that she gives to her figures three-dimensionally are also found in her drawings and prints.

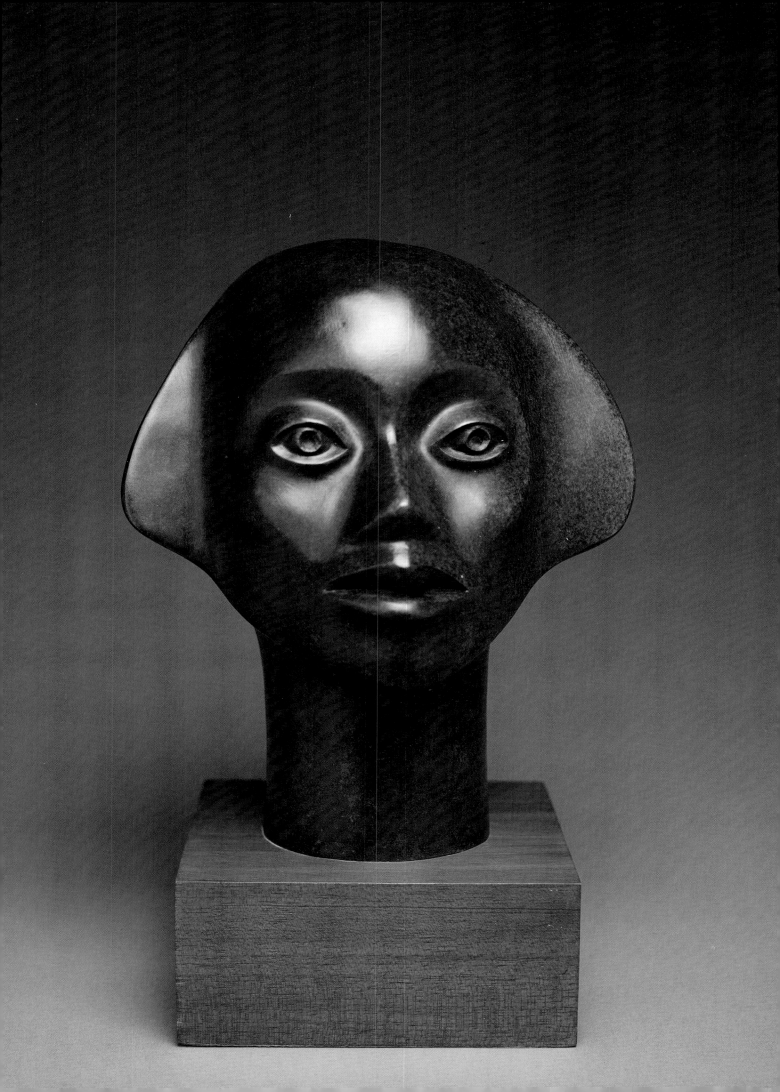

ELIZABETH CATLETT
Woman's Torso
BRONZE | 1998
© Elizabeth Catlett / Licensed
by VAGA, New York, N.Y.

The explosive energy of this torso is the central emphasis of this image. That this image is expressed in the center of the body of the figure, without the need to even represent the head and appendages, conveys the power of the female form as female, for in this torso is represented the beauty and essence of the body itself. Much like an expansive atom, the figure holds as its center the womb, the reproductive organs of the female form. The torso is the center of life, the essence of the miracle of life.

GRANT HILL: What a dynamic piece! Just through the torso, the artist has shown the character of this woman as one of great pride and confidence and love of her own life. It is amazingly expressive.

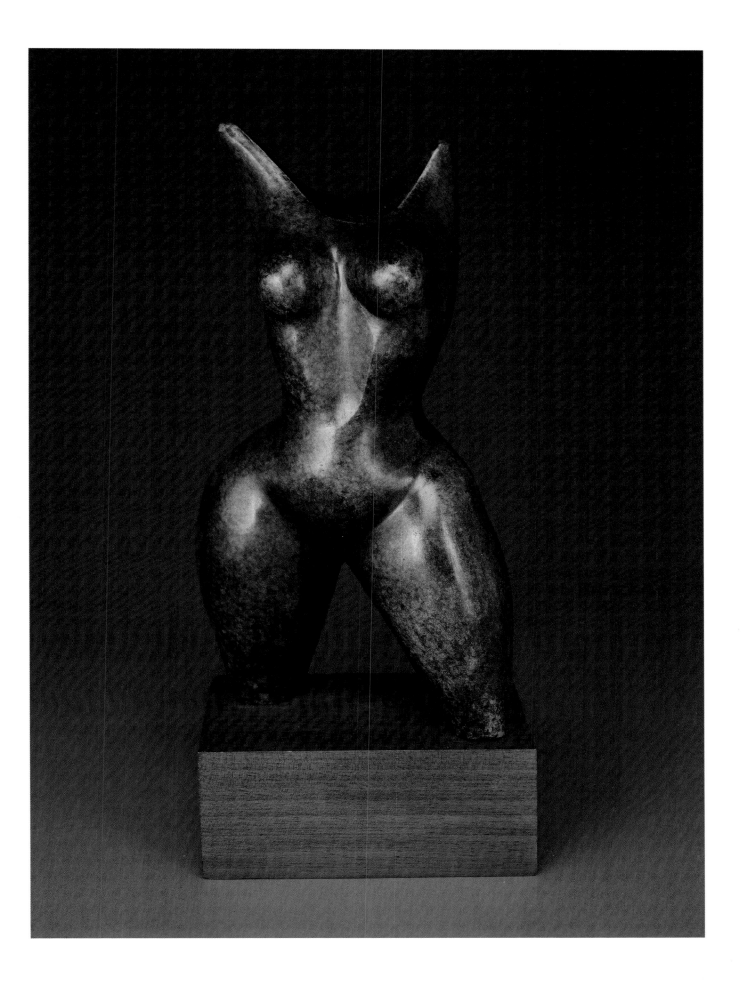

The onyx medium with its brilliant orange color contributes directly to the beauty of this work. Containing two elements, totally independent of one another, the work is a beautiful visual metaphor. In this work, Catlett revisits the theme of maternity with an emphasis upon both the dependence and the independence of the child. In this graphically dynamic work, the child is cradled within the mother like a human swing but given the freedom to move beyond, to be propelled outside of a safe beginning (the mother) into the unknown (the world).

GRANT HILL: The design of the child seated within the mother's arms, yet free and independent from the mother, captures the ongoing relationship between a mother and her offspring. The symmetry of the work is very beautiful, and yet the artist captures the mood of the mother as very reflective while the child is joyful and "in the moment."

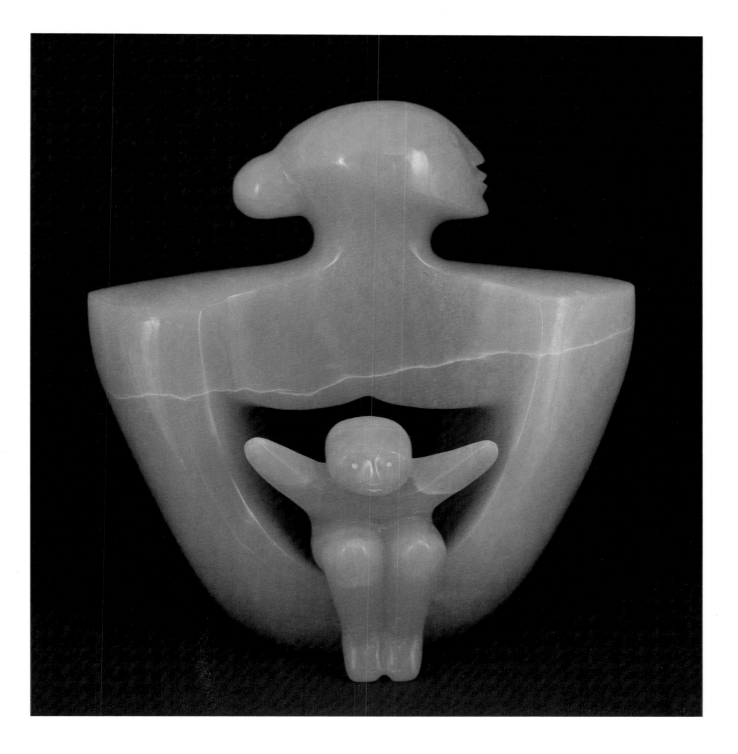

The stone medium provides a weighty presence to this figure, reclining in a natural state. Here the stone gives a presence to the form that is solid and formidable. The medium and the simple form call to mind Meso-American carvings—their monumental form and the simplicity of their surface carving.

GRANT HILL: This work reminds me of the heritage of Mexican sculpture that Elizabeth Catlett has been surrounded by for many decades. The massive nature of the form and the simple dignity of the figure remind me of Diego Rivera's murals.

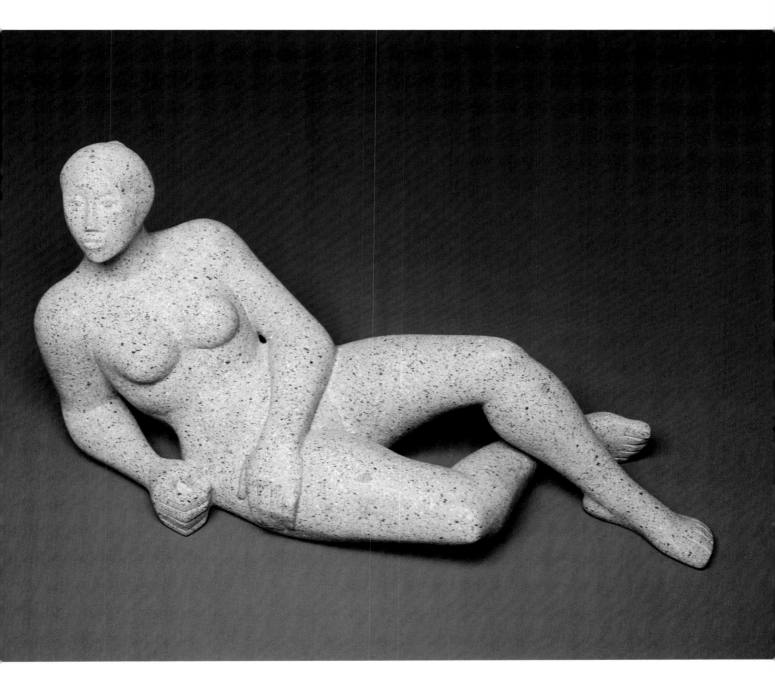

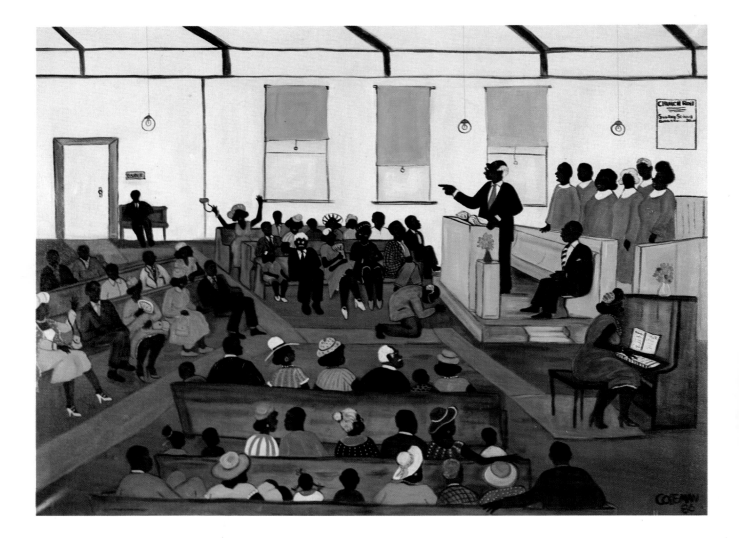

JOHN COLEMAN
Church Service

OIL ON CANVAS

32 x 42 inches | 1986

Depicting the very traditional country church service with simple interior, the Texas artist John Coleman uses the ruggedness of his painting style to underscore his surroundings and the folk quality of the figures and their environment. There is a very real quality of human interaction that Coleman has captured in his composition, and the many exchanges and activities enliven the painting throughout.

GRANT HILL: This painting reminds me of the many dedicated church members within the black communities that thrive in the American countryside. It is groups like these that become the backbone of social change.

Coffee Break

OIL ON CANVAS

30 x 36 inches | 1993

The relaxed intimacy of this setting is reflected in the exchange of conversation between the two men. The modest interior suggests an honesty that also seems to exist within the friendship. Coleman specializes in genre scenes of the black community, especially in the Southwest. Drawing from scenes around him, Coleman creates works that strike an immediate chord of human recognition.

GRANT HILL: This work is a very comfortable piece to live around. It is really like an extension of everyday life itself. It is these small moments of friendship that define one's quality of life and give a friendship its true characters. These are the memories that we collect.

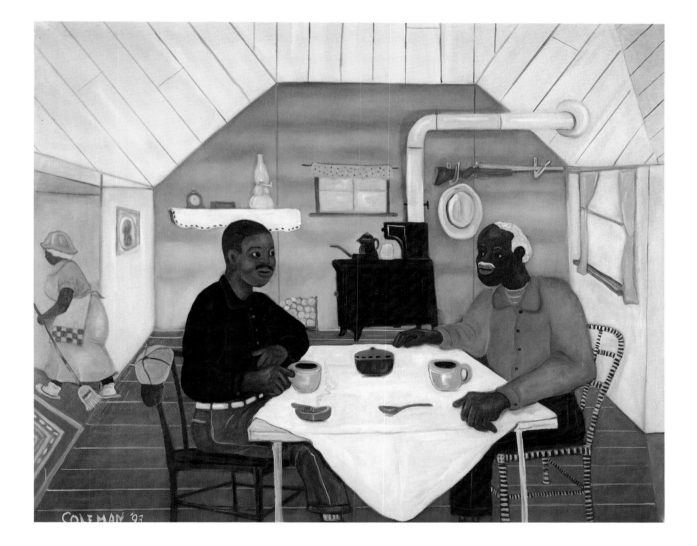

JOHN COLEMAN

Eight Ball

OIL ON BOARD

24 x 48 inches | 1992

This genre scene by John Coleman depicts the vivid activity of a pool hall, with players, several of them women, leaning over tables, attempting to get their best shot, while many wait in expectation for their turn, carefully watching the game. A game of cards holds the attention of three young men, while at the back of the room several customers sit at the bar in relaxed conversation with the bartender. Created in simple, bright colors of green, blue, rust, and red, the work recreates the texture of the pool hall experience and has a bit of action moving across every inch of its surface.

GRANT HILL: John Coleman has truly captured the energy of a big pool hall. He has all the details—putting the chalk on your pool cue, watching somebody else's shot, getting in the right posture to take your shot. It's as if the artist himself had spent more than a few hours at the pool table refining his skill.

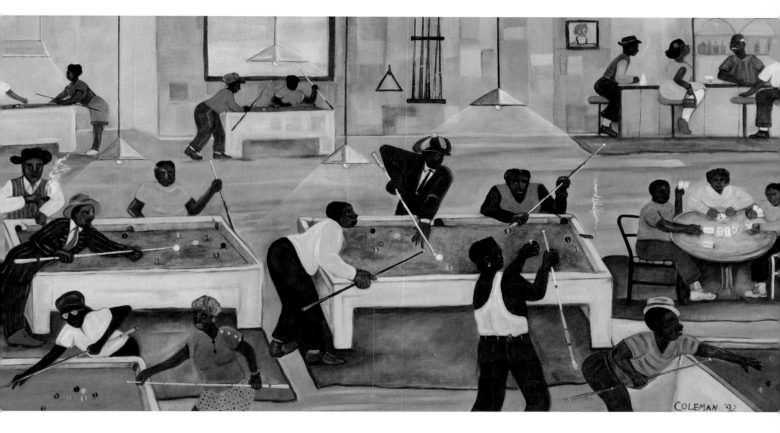

The mother and child seated together
underscore the bond of love and pro-
tection. At rest, the mother gives all
her attention to the child. The seated
figure has the bearing and weight
reminiscent of enthroned Egyptian
tomb figures, while her connection
to the child that she holds creates an
image of liveliness and intimacy that
belies the formality of the seated
pose.

GRANT HILL: It is amazing how
Ms. Catlett can interpret the move-
ments of young children, how at once
they are holding onto you for pro-
tection, while at the same time pull-
ing themselves up to look over your
shoulder to see what's happening
in the world.

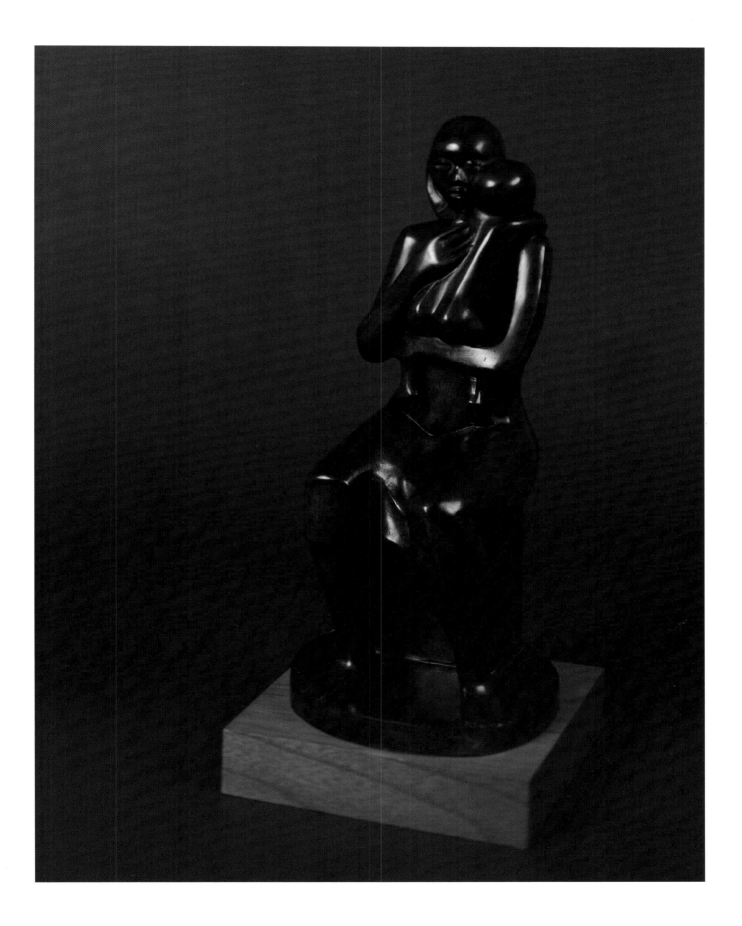

A smiling Malcolm, a sign of strength, seen from below, dominates this painting. In this work, Edward Jackson creates a figure that is the affable, accessible Malcolm, though appearing as if he is viewed from below a platform where he might be speaking. The smiling yet sharply intellectual Malcolm X is captured in this portrait; he is depicted here as offering a challenge, as a brother would, to be critical in one's thinking. It is interesting to note how many African American artists, both established and emerging, utilize their talent to depict icons of African American life such as Marian Anderson, Paul Robeson, W. E. B. Du Bois, Marcus Garvey, and Dr. Martin Luther King Jr. In recent years, the image of Malcolm X has also become increasingly popular as a subject for African American artists.

GRANT HILL: Malcolm X is a symbol to me, a figure who remains important in African American history as an indication of our need to be proactive in whatever cause we feel is important to support or lead. He represents the strength of black manhood, and the way that the artist has portrayed him, from an angle that makes him seem larger than life, is respectful and celebratory.

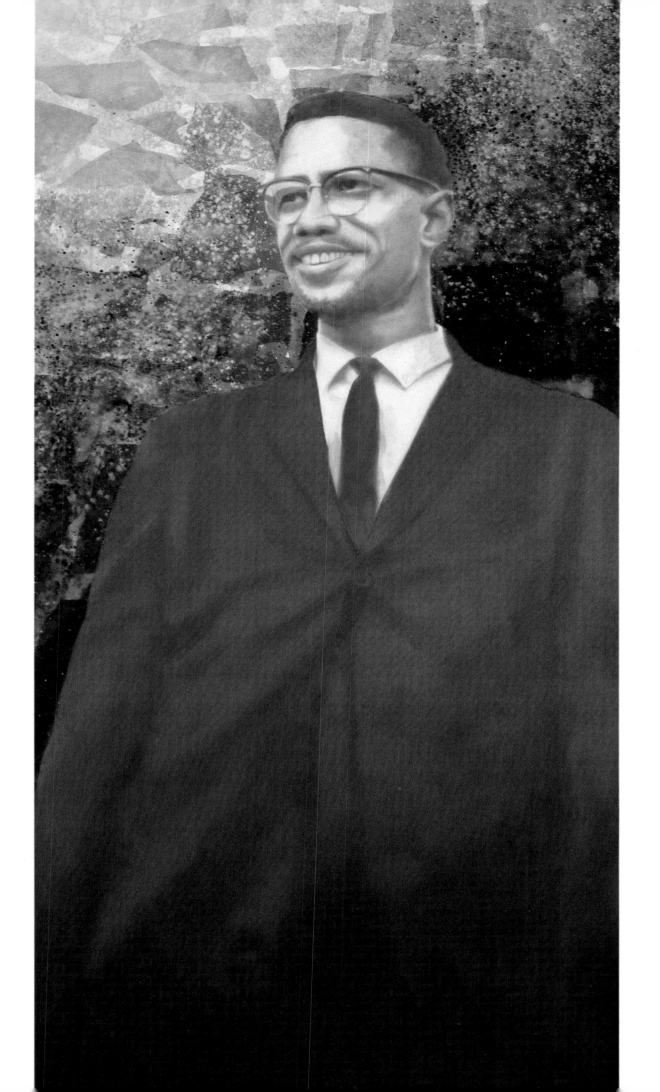

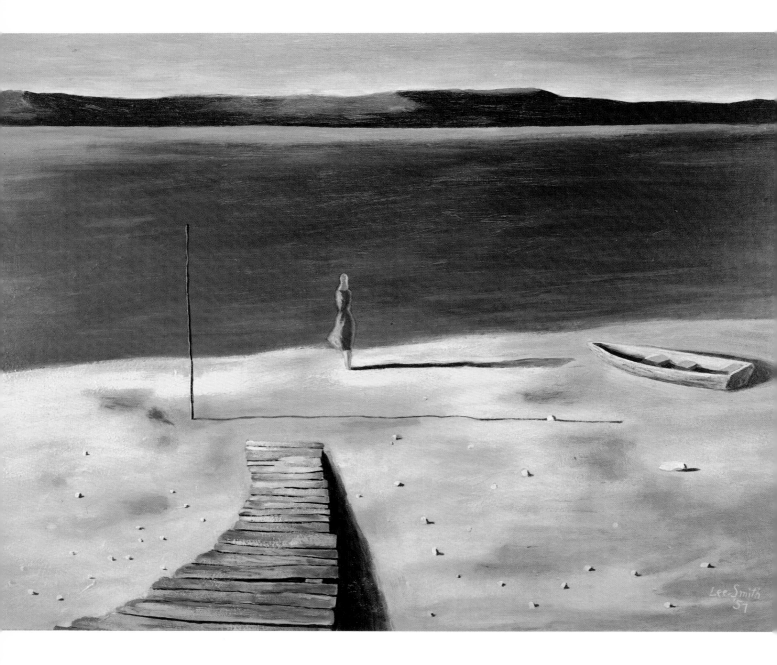

HUGHIE LEE-SMITH

Woman by the Seashore

OIL ON BOARD

17¾ x 23¾ inches | 1957

© Estate of Hughie Lee-Smith /
Licensed by VAGA, New York, N.Y.

A lone figure of a young woman contemplates the shoreline of a massive body of water. A wooden walkway leads to the beach behind her and nearby is a single small rowboat. Will she consider taking herself across the body of water in the boat, or is the boat's presence totally incidental to her presence? The young woman seems dwarfed by her surroundings. The only thing that stands with her is her own shadow. A profound sense of aloneness characterizes Smith's early works. Known for his focus upon individual contemplation, the artist painted during a period of existentialist expression among American intellectuals. Often compared to the American painter Edward Hopper, Smith in his works captures the psychological complexity of living in twentieth-century society.

GRANT HILL: I have often said that this work reminds me of my mother. I think of her standing on the shore in her mind as she made the decision to leave her home in New Orleans and attend Wellesley College. It is the moment of truth that is represented in the work that I find so strong.

Painted over thirty years after *Woman at the Seashore*, *The Letter* still investigates Hughie Lee-Smith's theme of human solitude. In this painting, however, the mood seems to be much more uplifting than in the earlier work. Standing in front of what appears to be a great academic hall with huge columns, a young girl holds a letter in her hand. Ribbons and balloons swirl about her in the air, indicating a moment for celebration. Unlike the other woman whom we can barely see, she looks directly at the viewer. She seems self-confident in her stance and thus in her future. Smith seems to have developed here a metaphor for success and potential in talented youth. The subject stands as upright as the column next to her, indicating that a great deal may rest upon her shoulders in the future. The close attention to the details of the surface of the concrete and granite steps and walls indicates the fluency that Smith had as an artist, his ability to move between very fluid and very precise passages of painting with great flexibility.

GRANT HILL: As I said earlier, Smith's *Woman by the Seashore* initially reminded me of my mother in her decision to go off to college. This letter could be her acceptance letter. Now that I am married and have a family, the young woman calls to mind the successes of my own wife and the future successes that I would want for my daughter. I like the fact that Smith can relate on a very simple level to the aspirations of people. He seems to know what is important to us.

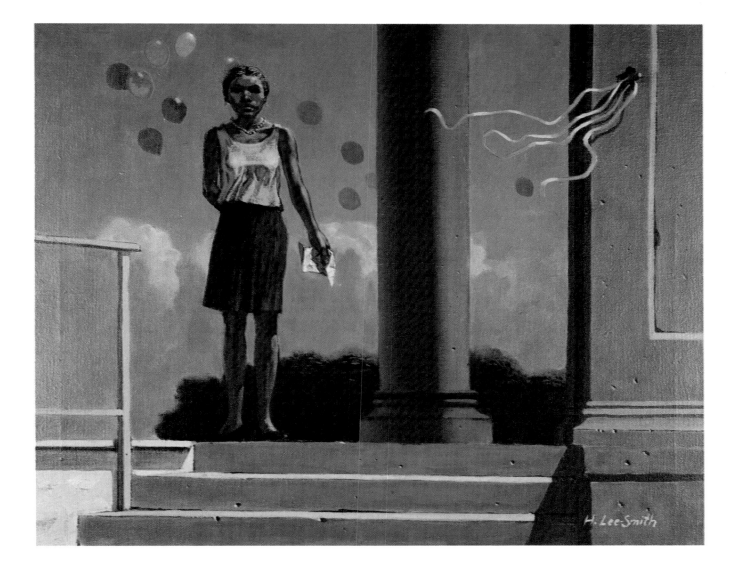

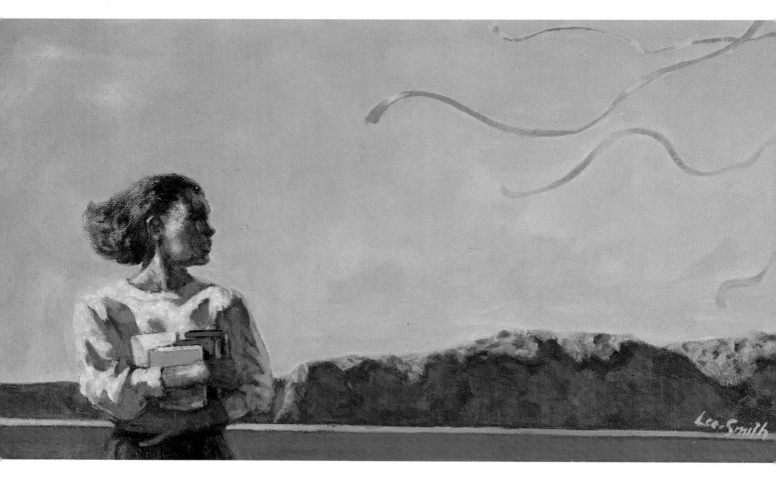

HUGHIE LEE-SMITH
The Dreamer

OIL ON LINEN

9 x 16 inches | 1999

© Estate of Hughie Lee-Smith /
Licensed by VAGA, New York, N.Y.

In this classic painting, Smith has created a beautifully poetic image of a young girl, holding a stack of books in her arms and looking off into the distance. She looks down the length of the painting, her hair blowing behind her, as if she contemplates her future. The books that she holds suggest learning, an effort at moving toward new horizons, possibly through studies or other endeavors. The work is classic Smith in its use of a lone figure against a natural background. However, this work has a much more optimistic mood than others which emphasize the solitary posture and isolation of the figure in often a much more brooding surrounding. In this work, the artist suggests change and promise by means of a single young figure and ribbons floating through the air. The relatively late date of the painting indicates a shift of mood in the artist's later years.

GRANT HILL: Once more Hughie Lee-Smith has captured our dreams. This young woman could be absolutely any young—or old—person who has cherished dreams but might be hesitant about setting them into motion. I think that the ribbon flying above the mountain in the background tells you that your dreams can soar above any obstacle. We simply need to set our sights high and keep them there. It is interesting to me that the artist painted this work when he himself was over eighty years old.

CONTRIBUTORS

ELIZABETH ALEXANDER is the author of three books of poems, *The Venus Hottentot, Body of Life,* and *Antebellum Dream Book,* and the forthcoming collection of essays *The Black Interior* (Graywolf, 2004). Her essays and reviews have been widely published in the *Village Voice,* the *Washington Post, Signs,* the *Women's Review of Books,* and many other outlets. Her poetry and prose have been collected in dozens of anthologies. Alexander has taught at Haverford College, the University of Chicago, Smith College, and New York University, and she has received grants from the National Endowment for the Arts and the Guggenheim Foundation as well as the Quantrell Award for Excellence in Undergraduate Teaching. She is an associate professor (adjunct) of African American studies at Yale University and lives in New Haven, Connecticut.

JOHN HOPE FRANKLIN is a native of Oklahoma, and a graduate of Fisk University. He received his M.A. in 1936 and his Ph.D in 1941 from Harvard University. Perhaps best known for his study *From Slavery to Freedom: A History of African Americans* (1947), now in its eighth edition, Professor Franklin has written other works including *Racial Equality in America; Race and History: Selected Essays, 1938–1988;* and *The Emancipation Proclamation.* While Chairman of the Department of History at Duke University, John Hope Franklin was named John Matthews Manley Distinguished Service Professor. In 1995, Professor Franklin was awarded the Presidential Medal of Freedom as well as the NAACP Spingarn Medal. In 1998, he was inducted into the North Carolina Literary Hall of Fame, and in 1999 he became the first African American to receive the Truman Good Neighbor Award. John Hope Franklin

is currently James B. Duke Professor of History Emeritus at Duke University.

BEVERLY GUY-SHEFTALL, PH.D., is founding director of the Women's Research and Resource Center and the Anna Julia Cooper Professor of Women's Studies at Spelman College. Guy-Sheftall has published a number of texts within African American and Women's Studies, including the first anthology of Black women's literature, *Sturdy Black Bridges: Visions of Black Women in Literature,* which she edited with Roseann P. Bell and Bettye Parker Smith, as well as *Words of Fire: An Anthology of African American Feminist Thought.* Her most recent publication is an anthology that she edited with Rudolph Byrd titled *Traps: African American Men on Gender and Sexuality.* She has also completed with Johnnetta Betsch Cole the monograph *Gender Talk: The Struggle for Equality in African American Communities.* A member of the Board of Trustees at Dillard University in New Orleans, Guy-Sheftall is the recipient of a Woodrow Wilson Fellowship and was an organizer of the groundbreaking conference Black Women in the Academy, held at MIT and subsequently at Howard University. Guy-Sheftall participated in the Fourth World Conference on Women in Beijing in 1995. She is an avid collector of African American dolls and textiles from world cultures.

CALVIN HILL is currently a consultant to Jerry Jones and the Dallas Cowboys. A 1969 graduate of Yale University, Calvin Hill was NFL rookie of the Year for the Dallas Cowboys. He became the team's first 1,000 yard rusher and played in Super Bowls V and VI. In 1994, Hill received the NCAA Silver Anniversary Award. Mr. Hill has served as Special Assistant to Senator John Glenn as well as Special Assistant to the Director of the Peace Corps. From 1993 to 2000, Hill served on President Clinton's Council on Physical Fitness. He was instrumental in the establishment of the Calvin Hill Day Care Center at Yale University and has worked with the

National Association for Retarded Citizens as the organization's National Sports Chairman. He has served on the Executive Committee of the Yale University Development Board and as a member of the board of the Riverdale Country School in New York City. With his son, Grant, Mr. Hill has sponsored numerous enrichment programs including those that focus on the arts and humanities.

A 1994 graduate of Duke University, GRANT HILL has established himself as one of this country's most talented athletes. He was a major factor in the winning of back-to-back NCAA championships by Duke, and in 1993 he was named the nation's top defensive player. In his senior year, Grant was unanimously voted first team All-American. He was named to the NCAA All-Tournament Team and was the NCAA Southeastern Regional MVP. After graduating from Duke with a degree in history, Grant was the number one draft pick of the Detroit Pistons. Like his father, Grant was named Rookie of the Year, and he was a member of Dream Team III, representing Team USA at the 1996 Olympic Games in Atlanta. Grant is a six-time starting All-Star and a perennial fan favorite. In 2000, Grant signed with the Orlando Magic. The collection of African American art that Grant has assembled is something that he hopes he and his wife Tamia can share with their daughter, Myla Grace.

MIKE KRZYZEWSKI was born in Chicago and is a 1969 graduate of the U.S. Military Academy. Winning seasons, superb graduation rates for his players, and a basketball team that is as close as family are all attributes that reflect on this Hall of Fame head coach of the Duke Blue Devils. In 2003, Coach K completed his twenty-third season at the helm of the program he guided to the National Championship in 1991, 1992, and 2001. He has been named National Coach of the Year twelve times and was selected as the Coach of the Decade for the 1990s by the National Asso-

ciation of Basketball Coaches. *Time* and CNN honored him in 2002 as America's Best Coach. His book *Leading with the Heart: Coach K's Successful Strategies for Basketball, Business and Life* was a New York Times bestseller, and his *A Season Is a Lifetime: The Inside Story of the Duke Blue Devils and Their Championship Seasons* provides an insightful look into the relationship that Coach K has with his players. Coach K is active in community philanthropy and is a strong supporter of the Children's Miracle Network, NABC Coaches vs. Cancer, and the V Foundation. Currently, Coach K is leading efforts for the development of the Emily Krzyzewski Family Life Center in Durham, North Carolina, named for his mother.

WILLIAM C. RHODEN has been writing about sports for the *New York Times* since March 1983. Before joining the *Times*, Mr. Rhoden spent more than three years with the *Baltimore Sun* as a columnist. From 1974 through 1978, Rhoden was an associate editor of *Ebony* magazine. A graduate of Morgan State University in Baltimore, Rhoden has written about numerous sports figures as well as issues related to sports in society. Rhoden was the writer for the documentary *Journey of the African American Athlete*, which won a Peabody Award for Broadcasting, and served as a consultant and guest for the award-winning ESPN series *Sports Century*. He is currently working on his first book, *Lost Tribe Wandering*, a political and cultural analysis of African American athletes.

An internationally recognized scholar in the field of African American art, DR. ALVIA J. WARDLAW is a graduate of Wellesley College and New York University. The first African American to receive the Ph.D. in art history from the University of Texas at Austin, Dr. Wardlaw has numerous exhibitions to her credit, including "Roy De Carava: Photographs" and "The Art of John Biggers: the View from the Upper Room," both organized for the Museum of Fine Arts, Houston; "Black Art: Ancestral Legacy: The African Impulse in African American Art," for the Dallas

Museum of Art; and "Our New Day Begun: African American Artists Entering the Millennium," for the Lyndon Baines Johnson Library and Museum in Austin. Most recently, Dr. Wardlaw was the project director and curator for the acclaimed exhibition "The Quilts of Gee's Bend." She is director and curator of the University Museum at Texas Southern University in Houston and curator of modern and contemporary art at the Museum of Fine Arts, Houston. Dr. Wardlaw has been a Fulbright Fellow for study in both West and East Africa and was a Compton Danforth Fellow at the University of Texas, Austin.

Library of Congress Cataloging-in-Publication Data

Hill, Grant.

Something all our own : the Grant Hill collection of African American

art / Grant Hill.

p. cm. Includes bibliographical references and index.

ISBN 0-8223-3306-6 (cloth : alk. paper) — ISBN 0-8223-3318-x (pbk. : alk. paper)

1. African American art—20th century—Catalogs. 2. Hill, Grant—Art collections—

Catalogs. 3. Art—Private collections—United States—Catalogs. I. Title.

N6538.N5H55 2004 704.03'96073'0074—dc22 2003018683